# The Video Camera Operator's Handbook

*This book is dedicated to*
*Fran, Nick and Tim*

# The Video Camera Operator's Handbook

Peter Hodges, FBIPP, FRPS, RIENG

Focal Press
An imprint of Butterworth-Heinemann Ltd
Linacre House, Jordan Hill, Oxford OX2 8DP

 A member of the Reed Elsevier plc group

OXFORD   LONDON   BOSTON

MUNICH   NEW DELHI   SINGAPORE   SYDNEY

TOKYO   TORONTO   WELLINGTON

First published 1994
Reprinted 1995

**British Library Cataloguing in Publication Data**
Hodges, Peter
    Video Camera Operator's Handbook
    I. Title
    778.599

ISBN 0 240 51314 2

**Library of Congress Cataloguing in Publication Data**
Hodges, Peter
    The video camera operator's handbook/Peter Hodges.
    p.   cm.
    Includes bibliographical references and index.
    ISBN 0 240 51314 2
    1. Television cameras — Handbooks, manuals, etc.   2. Camcorders —
    Handbooks, manuals, etc.   I. Title.
    TR882.H635
    778.59—dc20                                          94–32565
                                                            CIP

Typeset by TechType, Abingdon, Oxon
Printed and bound in Great Britain by Clays Ltd, St Ives plc

# CONTENTS

# PREFACE

In television circles one still rarely hears the word 'photography'. Considering that this is the visual medium for the masses, I find this quite remarkable. So this book has come about because of my determination to present video as a photographic medium. It is written from the visual point of view for all those who make pictures but particularly those in the front line of video shooting – camera operators.

One can understand that 30 years ago, when I first started work in television, it was intensely engineering-oriented. At the forefront of a technology that was still a mystery to most, engineers were an elite. I was one. I trained and grew up on a mixture of programme operations, engineering and good BBC practice where the visuals often had to take second place to the technical aspects.

I value that training. It was thorough, based on sound principles, and very extensive. As this industry now turns its back on so much of its past, I feel that those entering television are handicapped by not having this foundation to build on.

This came home to me when I developed Vical. This was a new approach to video measurement for the non-technical. Many users saw its value as a training aid and so the instruction manual reflected this and was rewritten and expanded into an operational manual. Thus the seeds of training and writing were sown.

This book came into being from the course notes of my training Masterclasses. It became impossible to say all I wanted about video, in a one-day course.

It is, therefore, to Avril Rowlands that I must first give acknowledgement. It was she who simply said 'You can't say it all, so why don't you write a book?'.

I want to thank Margaret Bradley for her very clear head as she ploughed through the first drafts. Her comments set me on the right course.

Also, I must thank my friends at BBC Pebble Mill, without whose assistance the project would not have been completed.

<div align="right">Peter Hodges, 1994</div>

# INTRODUCTION

This book is for all those users of video who feel a need for a better understanding of the system. It is at the operational level that, I feel, there is most risk of misusing the exceptional power available with video photography. Although the book is written around camera operation, the fundamentals apply to many areas where similar problems of picture creation and display arise.

Photography can be both very visual and very technical, depending on the individual and what his or her aims are. But the outcome must be visual for the audience, for they have no interest in the technical aspects. Hence the reader will find the 'how we view the picture' takes up a very large part of this book. The photographer should be able to approach both film and video with the same background and expect similar results, given the inherent differences between the two.

It is not the intention of this book to aim at just one level of skill; there should be something for all. But the newcomer is particularly in mind when discussing the video system with regard to the pictures it makes. The book starts with the video system and how it all came about. This background says a great deal about why video works the way it does. The technical aspects are dealt with in detail where they influence pictures. At the same time, engineering is kept at a respectful distance.

Video started as an engineering-controlled medium, and this is still the case, except that this is now carefully hidden away in microprocessors behind tiny buttons and black plastic. Our modern electronic wizardry allows the average mortals to distance themselves from the need to understand. But what of the professionals? How much do we need to know? How much can we avoid knowing? It is to answer these questions that this book has been written.

Television gave rise to modern video and it is worthwhile going back to those roots to see the emergence of video as a photographic medium in its own right. We often think of video as a product of electronic miniaturization, and superficially this true. But much more is owed to traditional 'heavy' electronics than is at first realized. There is the terminology, 'pedestal' for instance; what has 'pedestal' to do with a picture? Well, there is a clue in the term, but let us leave it at that for a while.

The important differences between television and the movie lay in neither the programme material nor the technology. Rather, one was instant while the other was not, and, one was home-bound. These differences directed the paths that each followed over subsequent years. Once this dualism of the moving image had become established, then retrospective changes to the systems would inevitably be limited by the systems that created them. For video this compatibility has always been a limitation.

There were other factors that aided the distinction; television was small screen, film large screen. The two have crossed paths but their backgrounds are still evident in their pictures. Technology and programmes are complementary; they develop together in a process of mutual stimulation. Either is able to push forward the visual experience. The intention is to open up the video system for all to see. It is a good photographic medium when used properly, just like film.

The book sets out to provide knowledge of the video system and to present to the reader some thoughts on pictures and lighting where they are particular to, or influenced by, this system. There is inevitably some crossover into these subjects, but there is no intention to offer definitive dissertations here, but rather to encourage further reading and study based on a better understanding of video.

The discussion covers various topics that are particular to video production. These may appear at different stages throughout the text where further investigation is of value. Specifics, such as 'which camera', are carefully avoided, the discussion being kept much broader than that and aimed at the principles. The only specifics are the elements of the video system and how these are used. Where comparison with film is considered useful, this is included.

There are many instances where I have made a short cut through technical matters. To the purist this may be alarming, but I have concentrated on the pictures. The engineering will look after itself if it is treated with the respect that comes from better understanding.

# CHAPTER 1

# TELEVISIONS AND TELEVISION CAMERAS

My first experience with a hand-held camera was in 1964. It looked like a pipe some 100 mm in diameter and 600 mm or so in length, with a fixed focus lens at one end and a thick cable at the other. The cable was attached to a large heavy box with an engineer in constant attendance. This was a very limited operation by today's standards, but it worked so well that seven heavyweight cameras stood idly by. This was theatre, larger than life, a fight scene. There were dramatic close-ups, for the first time right inside the action. The camera was Japanese, the name was Ikegami. But before we can view the camera there has to be a screen....

Which came first? There was little point in making a camera until it was possible to view its product. The father of modern photography, Fox Talbot, created reliable printing. There were already lenses in boxes (camera obscura) and light-sensitive materials. Fox Talbot made possible the taking of reliable pictures. How we view them affects how we photograph. Experience tells us that the taking and viewing of a picture are interdependent. Do you ever turn a print over to see who manufactured the paper?

It could be argued that the ideal viewing medium should have no influence upon the picture but this would be impractical and would, in itself, remove a very creative visual tool available to the photographer. But you have to be able to view your pictures reliably, for this is just as important as creating the picture in the first place.

The cathode ray tube (CRT) was the first satisfactory display method for electronic pictures, soon to be known as 'television'. There were a number of far-reaching ideas in the minds of eminent engineers and scientists of the time who were to make use of this device. It was a development of the radio valve, and so it was within the capability of industry to produce it in large numbers. This was in the late 1930s; radar was receiving considerable attention, and the CRT could show what radar detected.

As part of this work, the potential of the CRT as a picture display device also came under investigation. Television and radar shared many development features, and EMI and others worked hard at producing reliable and practical tubes. Today the principle is unaltered. The CRT still has the greatest influence over video pictures, as its characteristics are quite far-reaching.

Although the original tube has been improved over many years, incorporating one technical refinement after another, the basic design remains unchanged. The early system made use of not one, but two CRTs: a picture tube and a camera tube. These were developed simultaneously. The concept is simple; light focused onto the camera tube is converted to an electrical signal and transmitted to the picture tube and converted back into light. Inevitably there were shortcomings in the system that made this ideal unrealizable.

Ignoring for the moment the fact that the display was monochrome, the two most significant shortcomings were as follows. First, the size of the display made it technically difficult to make large displays that were bright enough. Second, but less obvious, the picture tonal range was distorted, the light output of the screen was not in direct proportion to the light input to the camera. The resulting picture had a 'soot-and-white-wash' look, for the effect compressed the darker tones whilst expanding the lighter tones. Many readers will still remember the pictures of the early television sets. The contrast of the picture was strange, producing dark eyes and a lack of mid-tone grey. There was poor resolution that obliterated fine hair and facial detail. The picture was small and not very bright. They were also unreliable, particularly as the picture set-up was very liable to drift. To the viewer of the day, reliability assumed importance above everything else.

Others thought differently and broadcast engineers toiled to develop and improve their system. The receivers were largely the province of the set manufacturers and it must be said that customer demand steadily brought about better-looking pictures that were more stable and reliable.

## Tonal value distortion: the compression of picture greys

Why does this happen? In practice we do not get values of light from the CRT screen which correspond exactly to the video signal applied to it. At black, no light leaves the screen; this is our picture black. Raising our signal above black means that the screen produces a certain amount of light and becomes grey. Increasing the signal further makes the grey lighter, and so on until we achieve white. This is no more than we would expect. So what is the problem? Unfortunately, our signal is measured in volts and is quite precise, and the difficulty arises because of the design and construction of the CRT. These features make it less responsive to changes of signal in the darker parts of the picture. In the brighter parts the opposite applies, and so for equal values of signal we do not get equal values of light from the screen. The darker tones are more compressed whilst the higher tones are more expanded.

Tonal value distortion is pictorially very important to the photographer, but a far more unpleasant problem existed in early television; this was 'snow' or electronic noise. This was caused by reception difficulties, and when it became serious there was only one course of action open to the

viewer – to switch off. Remember, this was 405-line television in the 1940s and 1950s. A picture was a picture, whether tonal values were correct or not, but noise was a real problem. The most vulnerable part of the system to noise was the transmission chain, that tenuous path between transmitter and television set. Reception near Alexandra Palace was fine, but as the service crept up the Welsh valleys reception of a good signal became more and more difficult.

But there is a twist in the tale. As noise is subjectively more objectionable in the darker tones of the picture, and as the picture tube compresses these, it follows that noise will also be compressed. And so the correct tonal value reproduction had to wait for further developments.

This was all very unfortunate, for film was now showing very even gradation of tonal values, and good sharpness from the high-resolution stocks available, on large screens. Early television was a poor performer by comparison. Initially only limited work was carried out to improve grey rendition. It was, in fact, left to the craft and design skills of make-up, costume, scenery and lighting to improve reproduction of those darker areas of the picture. With lighter eye make-up, lighter costumes, lighter sets and the photographic skills of television lighting, considerable gains were made for the viewer.

Photographically the control or manipulation of tonal values at the taking stage was not new. Film had dealt with similar problems that arose from the less than perfect emulsions of the day. In any case, photography in black and white had considerable experience with the manipulation of tonal values. Changing the relative values of picture greys by exposure control and development was a well-established technique. Study the work of John Ford, or the photography of *Citizen Kane*. From Russia, Eisenstein's *Ivan the Terrible*. One can go on. This valuable creative tool is a darkroom technique that stills photographers are well used to today. Film reproduction on television often displayed a more even tonal range, as attention was given to this in film development and telecine machines.

## Colour arrives

It was colour that forced the issue. Colour is, by its very presence, an indicator of reality. The eye sees colour in real life, and therefore with colour reproduction we become much more aware of false values. Distortion of tonal values will quickly make our colour picture less convincing, or even unacceptable. Tonal distortion also falsifies colour saturation.

Attempts had been made to solve the problem before colour arrived, for outside broadcasts were appearing and, as any landscape photographer knows, you have to shoot what is there. There is no scenic manipulation in the real world. Good noise immunity was still an important issue and so the receiving set was not the place to correct the problem. Instead it was to the camera that engineers turned their attention.

They chose to deal with the problem before any noise could get in to

the system, right at the beginning. This elegant solution was a classic engineering one, and the two problems were solved in one. But we are left with a legacy. Now there are uncorrected picture displays and pre-distorted cameras. Thus, the transmission chain between the two is non-linear.

This situation is often not realized by users, and this fact alone must be a testimony to its success. But let us consider the implications. All new designs of equipment, whether display or imaging, must comply with this rule established so many years ago.

## How sharp and how small?

In what other ways do picture tubes influence how video pictures are created? Tube displays are traditionally small. They are also low resolution. An equivalent photographic print has far greater resolving power than the tube and therefore looks much sharper. This has resulted in quite a different approach to making television pictures. The small box in the corner of the room occupies a fairly small part of our vision and so exhibits different visual values to the larger cinema screen. Movement in so small a picture is a vital element, and used effectively helps a great deal in offsetting the small-screen effect. Compare the viewing of stills on large and small screens. For example, Photo CD allows film stills to be seen on a television screen, and a video projector allows the reverse. In the first case the fine scenic detail recorded by film will not be seen; this effect is particularly noticeable in landscape shots. The second case reveals in large screen splendour what a low-resolution medium video really is. This dichotomy indicates a misuse of the two mediums that has become established practice and a fact we cannot now ignore in our photography.

The small-screen, low-resolution medium has resulted in the development of sharpness enhancement, referred to as detail. This is false sharpening of the picture applied in the camera. In simple terms it can be described as drawing an outline around elements in the picture to make them more distinctive. The resolution of the early monochrome cameras was really quite good and needed no such assistance. As camera tubes developed they became more sensitive and even sharper; there was a large imaging area that was comparable with 35-mm cine film, for which a range of excellent lenses was already available for adaptation. When colour came along with three-way colour analysis that demanded three tubes, the first colour cameras were consequently enormous. To bring the size down, smaller tubes were needed, bringing with them a smaller image format and, inevitably, lower resolution. 'Detail' was introduced. This was a sophistication in image improvement, made possible by the developments in signal processing of semiconductor electronics.

Things have moved on, improvement by improvement, from camera tubes through to charge coupled devices (CCDs). The continued striving for smaller cameras and smaller lenses means even more sophisticated enhancements.

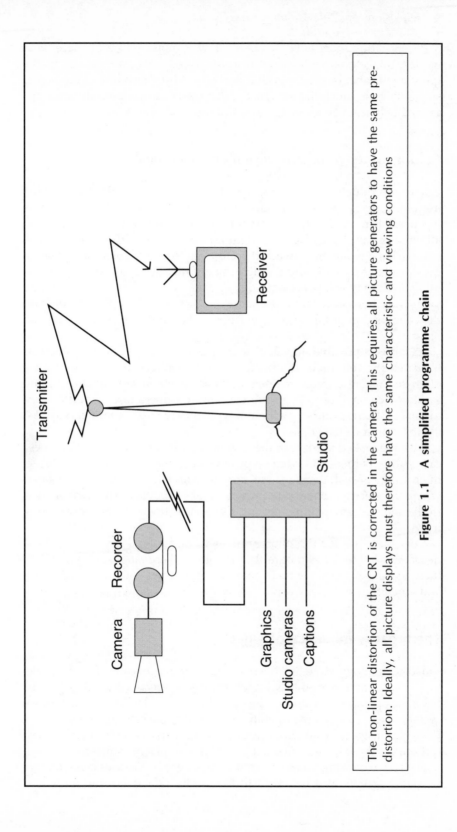

The non-linear distortion of the CRT is corrected in the camera. This requires all picture generators to have the same pre-distortion. Ideally, all picture displays must therefore have the same characteristic and viewing conditions

**Figure 1.1  A simplified programme chain**

Receiver designers have not been slow in making use of these techniques. Image sharpening may also be added here, particularly in the growing number of small portable sets where tube resolution falls foul of size. This is so much the case that sometimes this may entirely mask the refined enhancement of image detail in the modern camera.

## Colour: other problems, visual and technical

Colour reproduction is the final consideration. There are three phosphors used in picture tubes to create the colours red, green and blue. From these it is possible to produce any other colour – or so the theory states. Turn off all three and we have black – no light leaves the screen. Turn them on full and we have white. In between there is every value of colour and level of grey available by choosing the right mix of the three. In making, say, the purest red, only one phosphor will be turned on – the red one. There are many variations of red, and the actual red we get will depend entirely on the composition of the chosen phosphor. The same applies to green and blue.

As far as is possible the television system uses camera colour analysis to match the colours of the picture tube phosphors. In spite of this we often see where different cameras mismatch when reproducing certain saturated colours, revealing differences from camera to CRT and camera to camera. In the same way different types and makes of receiver may also exhibit colour differences.

We have looked at some of the technical problems of video – how these came from its roots and what steps have been made to use them, correct them and conceal them. These are the variables. Variables appeared where the electronics failed to provide total confidence. The variable was the point of human intervention. Originally this was an engineering input.

Now these are for the photographer to understand because the final decision is left to the photographer. It is his or her responsibility to know these variables, to realize their potential and to say when they will work and when they will not work.

## The broader influence of video

Video technology stretches beyond video and television. For example, there are computer graphics systems. What corrections do these have? Does the operator understand the distortion of tonal values in the display system used? Or does the operator rely on the machine to come up with the right answer? What about liquid crystal displays (LCDs)? What distortions do these have buried behind their slim plastic panels?

The rule regarding tonal values must still apply. Pictures created from whatever source must be pre-distorted to offset the distortion present at

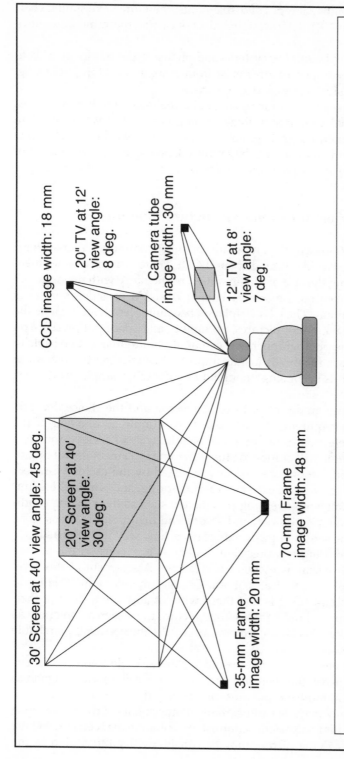

30' Screen at 40' view angle: 45 deg.

20' Screen at 40' view angle: 30 deg.

CCD image width: 18 mm

20" TV at 12' view angle: 8 deg.

Camera tube image width: 30 mm

12" TV at 8' view angle: 7 deg.

70-mm Frame image width: 48 mm

35-mm Frame image width: 20 mm

The diagram is a simplified comparison of display and format sizes for cinema projection and early television. Television's low definition is acceptable with a viewing angle of only 7 deg. The modern video viewing angle has improved but still falls short of that in the cinema. Lower video resolution shows up when viewed at wider viewing angles

**Figure 1.2   Viewing angles**

the end of the chain. All types of display must therefore have similar characteristics to the CRT, for the signal always carries the same amount of pre-distortion.

With so many blossoming systems and offshoots there is greater likelihood of error. Examples of error exist from video to desktop publishing, and in film transfer to large video screens.

The appearance of the semiconductor and the microchip has made possible phenomenal advances in image manipulation. But we must retain our executive control over these for it is not an ideal world of perfect picture displays and cameras. We have to understand the shortcomings of the system if we are to avoid the unexpected.

## Viewing your pictures reliably: picture monitors

The original CRT-based display is still the most common. Other systems are based on the liquid crystal display (LCD). There is much development aimed at reducing the size of picture tubes, particularly with regard to the physical depth behind the screen. Weight is also a consideration, as is power consumption. The CRT display is becoming less than ideal as the demand for bigger, wider pictures, portability and space put pressure on engineers. To the photographer, one essential point remains: to be able to view your picture reliably is just as important as creating the picture in the first place. It is surprising, though, how often this simple principle is ignored.

There are many grades of picture monitoring and the choice depends on the viewing requirements and cost. For example, at one end of the scale, for the detection of the presence or otherwise of a video source, a very basic monitor will suffice. At the other end, a camera of full broadcast specification can only be properly assessed by the use of a Grade 1 monitor. These are the two extremes of monitoring, and within these limits is a whole range of governing parameters such as the viewing conditions, the screen size required, and so on. The final point that has to be considered is the set-up of picture display, or how well it is adjusted.

Grade 1 monitoring is a precision system. It is expensive and is only used where full visual assessment is required. Assessment at this level may be pictorial or technical or both. Grade 1 monitors are able to do both. The important thing is that these will not add any artifice of their own to the picture, allowing the source picture to be seen as precisely as possible. It follows that Grade 1 monitors should always display a reliable and stable picture.

At the other end of the scale, using a standard television receiver is much less expensive. But there are pitfalls. First, receivers are designed to obscure technical faults on pictures, or, at least, they are not designed to reveal them. They may also add certain enhancements of their own, such as sharpening and increasing contrast or colour enhancement. Whilst such alterations to the picture may be considered legitimate and in the

best interests of the average viewer in the home environment, they are of little value to a photographer in the assessment of pictures. They are, after all, deceptions.

Nevertheless, there has been a steady increase in the use of receiver-based monitoring on the grounds of cost and convenience. In recent years receivers have improved in a number of ways: reliability, size, power (battery power is now common) and light output. Much of this is attributable to developing technology but the bottom line is automated production. Increasing sales volume makes automation viable, and automation means a tighter specification, bringing consistency and reliability. Receivers may not provide perfectly accurate pictures but their consistency and reliability constitute a major step forward for we can at least get to know a display that is reliable.

So what are the pitfalls? In describing the background to television with regard to taking and viewing pictures, tonal value distortion has been considered. This effect is a not uncommon feature of many conversion processes; film exhibits the effect when exposed and again in the printing stage.

The technical term given to this is gamma and it is a measurable quantity. It clearly follows that a picture source must have the precise value of pre-distortion if it is to correct an error in the display. It also follows that all picture sources should have the same pre-distortion and all displays must have the same error. Therefore all displays from Grade 1 monitors to portable televisions should have the same gamma. In practice this is not always achieved. Receivers are designed for different situations where high levels of ambient light are commonplace, and this factor alone accounts for the most serious discrepancy between home and studio viewing conditions. The Grade 1 monitor is designed to operate in subdued light, for the brightness of the picture is secondary to its precision. Use outdoors, or even on a studio floor, will almost certainly render the superior features of the Grade 1 monitor useless and even misleading.

The concept of gamma is important, for it has become rather loosely applied and is now sometimes surrounded by confusion. Gamma is discussed in more detail in Chapter 7.

# CHAPTER 2

# THE VIDEO SIGNAL AND MEASUREMENT

We measure to guarantee the quality of our work. Reliability and repeatability are the important features. All photographers measure light to obtain values of exposure. Allowing the camera to do this is one way, but in doing so it will make its own estimate.

## The waveform: how the picture is built up

Electronics have become so sophisticated that they will quite happily measure everything, but it is still the responsibility of the photographer to make pictures. Letting the equipment do so is bad practice. To understand the equipment is to know how to manage it. It is a mere tool in the creative hands of the photographer. As such, its foibles and virtues must be understood. There are two separate reasons for measuring: an operational one, exposure being an example; and a technical one, to ensure that the equipment is producing what we expect, i.e. a standard video signal.

The need for the first is obvious to a photographer, but what about the second? With film we have come to rely on the film manufacturer to produce stock that is reliable and predictable and which, when printed, produces consistent results. Video is just as able to do this, but unlike film it has a great many variables.

Electronics are wonderful at manipulating, permitting calculations of phenomenal complexity to be handled in microseconds. In a camera it is very easy to bring all parameters to a microprocessor, let it work out new values and send out instructions to implement them. But it is important to know what these values are if we are to retain our control over pictures. At the very least, we should know when changes are being made. No film does this, for film is a passive medium. To have everything under control, nothing happening that we do not know about, is to work like film. Video can be like this but it has to be understood.

Choosing a film stock should be the same as choosing a camera line-up. This information is held in the camera itself, either in microprocessor memory or by discrete controls, or both, and is available for

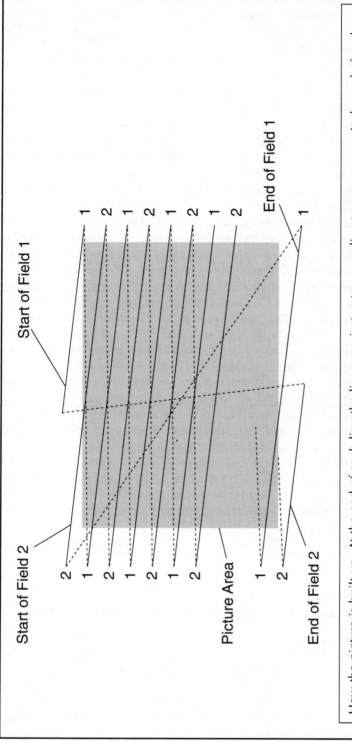

How the picture is built up. At the end of each line the line sync instructs a new line to commence. At the end of each field the field sync instructs a new field to commence

**Figure 2.1   Line structure and interlace**

investigation from the video signal. To understand this means delving into a little engineering; we do not have to do a great deal of this but a little effort to understand will repay well in the end. Let us start with the construction of a video picture.

Taking the television CRT, light is produced by an electron beam exciting the phosphors deposited on the inside of the screen. As the beam moves, a line is traced across the screen. Then the next one is traced beneath the first, and so the picture is built line by line down the screen. Compare this to a printed picture, which is built up with a fixed dot structure. The spot size produced by the beam is as small as possible and represents one pixel, the smallest picture element. Lines are traced from left to right, the beam quickly returning at the end of each line to start the next. A frame is completed at the end of the last line and the spot returns to the top to start all over again.

As each point of phosphor is excited by the electronic beam, it emits light and then slowly decays after the beam has moved on. Where the picture is black the beam is turned off but the mechanism that moves it continues, for the video picture always follows this regular routine. So we have a picture constantly being updated line by line, frame by frame. This repetition results in an observable flicker and, to overcome this problem, a solution similar to that used in film projection is made use of. The frame is broken into two parts, doubling the flicker rate. Under average viewing conditions, the eye cannot follow changes in the image if they occur faster than one-fiftieth of a second, so making observable flicker much less objectionable.

A frame is therefore constructed from two fields. These are not identical for their line structures are interlaced. To understand this, imagine the fingers of one hand placed between the fingers of the other; this is interlace. Because the fields are not identical they are identified as Field 1 and Field 2, or as 'odd' and 'even' respectively.

In the simple system of camera and receiver, the camera is master and instructs the receiver to follow its picture-making process, line by line and frame by frame. The receiver is programmed to create the picture as described and requires the following information from the video signal to do this:

1. The picture information.
2. How to reconstruct the picture.

## The waveform: putting picture and engineering together

It is possible to monitor the actual waveform to see its structure and the representation of the picture present. Seeing the signal graphically allows us to evaluate it and ensure that it is within specification. We can see the level of picture present and, although not easily related to specific picture elements, this is an important and established technique for measuring picture signal level (analogous to the audio VU meter). Such observation is carried out on a waveform monitor (WFM).

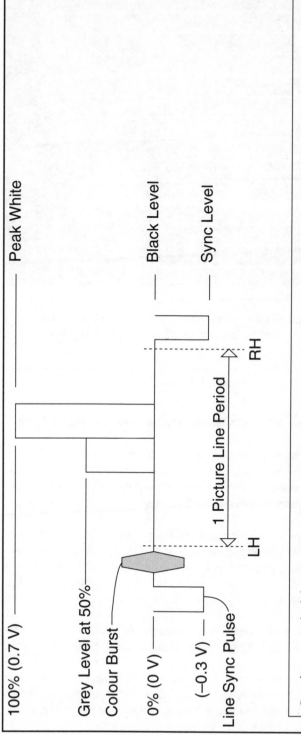

100% (0.7 V) ——— Peak White

Grey Level at 50%

Colour Burst

0% (0 V) ——— Black Level

(–0.3 V) ——— Sync Level

Line Sync Pulse

LH                    RH

1 Picture Line Period

One line period of the picture is illustrated. The waveform divides into two parts at black level. Below black is the synchronizing information that receivers and monitors use to start the picture scanning. This portion is never seen. Above black there are all the tones from black at 0 per cent, to white at 100 per cent. The picture occupies seven-tenths of the total video signal. Syncs occupy three-tenths. Also shown is the colour burst that gives information to the receiver about how it must translate the colour information also carried by the waveform

**Figure 2.2   The waveform of the grey and white bars above.**

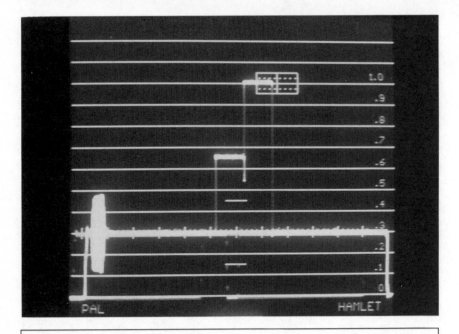

The waveform photographs are 'in picture' displays where the wave-
form is displayed on a standard picture monitor. (Courtesy of Hamlet
Video International.)

**Figure 2.3**

## Synchronizing: making everything happen at the right time

In the lower part of the waveform is a sequence of electronic pulses or
sync pulses. A complete waveform, consisting of picture and sync, is gen-
erated by every picture source. Even if we see no picture, i.e. only black is
present, sync information is still required to ensure that displays remain
synchronized to the source.

This engineering part of the picture is, of course, never seen. Its preser-
vation and accuracy is, however, vital, for faults occurring here will
invariably cause serious picture problems, problems that may be very
obvious at the time or hidden, only to cause difficulties later.
Considerable care is therefore taken in equipment design to reduce the
risk, or to warn if a fault does occur.

The difficulty arises when there is more than one picture source. The
receiver can only follow one set of instructions, so more than one picture
source will cause a clash at the receiver if an order of priority is not
established. The answer is to make one source master and the others syn-
chronous with it. Genlock (or sync lock) is what this technique is called.
By making the master available to the genlock inputs of the others, each
will slave to the master and start its picture in synchronism. With all

pictures starting at the same point in time, the receiver has no conflict and can follow accordingly. All we have to do is decide which will be master. But as this is a complex procedure it is best left for a while.

Measurement of the signal is normally in volts. A complete signal, measured from the bottom of sync to peak white, is 1 Volt. 'One volt of video' is the standard signal linking pieces of equipment, parts of the transmission chain, and even satellite links.

## Colour: three-colour system in one cable

You may have seen the experiment of pointing three lamps at a white screen. Each lamp has a different colour gel, one red, one green and one blue. Switch one lamp on, and you get that colour; switch all of them on and, with a little adjustment of the lamps, the screen becomes white. Switch one lamp off at a time, and we get the complementary colours, yellow with blue switched off, magenta when green is switched off and cyan without red. This is additive colour.

The monitor screen does exactly this. All colours at maximum make white; take one colour away, and we are left with the maximum value of the other two added together; take away two colours, and there remains the maximum value of a single primary colour. In each case the colour will be fully saturated.

The camera analyses the scene into red, green and blue (RGB); it may do this from three sensors (3 × CCD) or a single one, but whichever method is used, the final effect is processed by the electronics to be the same. The signal is transmitted and then reproduced as the original colours. Because the relative values determine the colour mix and its brightness, it is vital that all three are transmitted identically. Any distortion of one will alter the final colour mix. So the three channels must be identical; what is done to one must be done to the others.

So far we have not considered how colour is sent. On the photograph of the waveform (Figure 2.3) there is shown the colour burst. This is a reference that precedes each line of the picture, telling the receiver how to reproduce the colour accurately in that line. It is also important for other picture sources, via the genlock inputs, which use this reference as part of their synchronizing process.

To send colour requires considerable additional complexity. Information about colour is added to the existing black and white signal in the form of a colour subcarrier. This technique was developed to make the same signal work both colour and the existing black and white televisions. It is, therefore, a compatible system such that the older televisions were not disadvantaged by the broadcasters going over to colour. It was also necessary to protect the very delicate colour information during the rigours of the transmission process, because the eye is so sensitive to colour distortions. Embedding this information in a subcarrier is like placing it in an envelope, ensuring its proper protection.

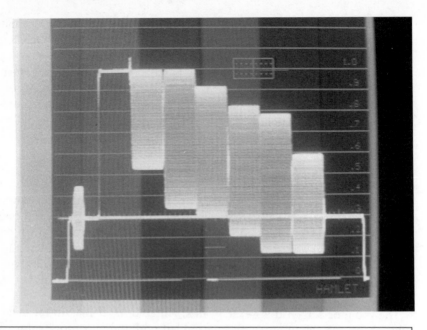

How colour is accommodated into the video system is explained by
observing the standard test signal: colour bars. This facility is available
on most cameras as a standard line-up signal for the tape, or down a
cable or line, before the actual programme. At the destination they will
be measured with a waveform monitor to ensure that they comply with
the standard. When colour bars are displayed on the monitor we will
see the whole colour system. Using the three colours, red, green and
blue, normally abbreviated to RGB, to reproduce all the colours of the
picture is standard to all videos. This is the original component video
and forms the basis for all picture imaging. The system is designed such
that maximum values of the three colours make white. Colour bars
contain all the information about the video signal necessary to check
it.. There are the primary colours and their complements, plus white
and black.

**Figure 2.4   Colour bars: the standard test signal**

   The signal now has three parts; syncs, picture and colour. The last of
these is combined with the picture, and to differentiate between these they
are referred to as luminance and chrominance. This is composite video.
   Colour transmission placed a very substantial demand on the technol-
ogy of the day, particularly that of the time measurement required to
establish accurate synchronism. Our original black and white system had
to sync up to an accuracy of half a microsecond. This may sound very
impressive but the one thing electronics achieved quite early was an

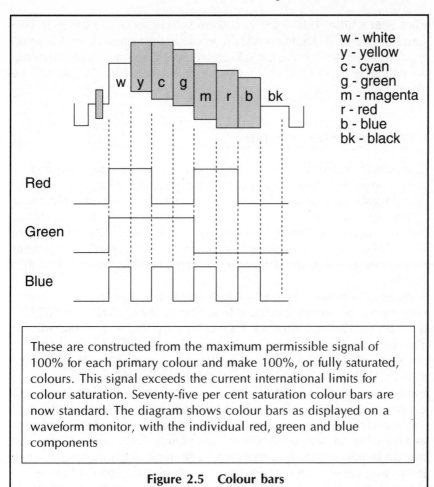

These are constructed from the maximum permissible signal of 100% for each primary colour and make 100%, or fully saturated, colours. This signal exceeds the current international limits for colour saturation. Seventy-five per cent saturation colour bars are now standard. The diagram shows colour bars as displayed on a waveform monitor, with the individual red, green and blue components

**Figure 2.5   Colour bars**

ability to measure very small periods of time. In due course, when colour television was in its development stage, such measurement was normal practice in a wide range of applications from radar to counters.

This feature was made good use of, for the information about colour is carried as a time-related code. The colour burst which precedes each line provides a reference for the receiver. This prepares the colour-decoding circuits for the scene colours present on that line which in turn will say what levels of red, green and blue are to be produced by the picture tube. To do this we have to measure in nanoseconds, a nanosecond being a thousandth of a microsecond. This is very critical timing indeed.

## Is television really so simple?

To explain the essential principles of such a complex system in terms that a picture-maker can understand requires that corners are cut and a few

rules bent a little. This is the waveform behind video explained in very simplified form. It is not necessary to know all the technical detail to make good video pictures, but it is the foundation of video and in later chapters we will refer to it to understand better how to produce the pictures we want.

## Component versus composite

Component video is where the signal is transmitted, recorded or processed in its component colours. This requires three separate and identical systems, making it an expensive and elaborate method compared to composite. But there is one advantage. Composite video has the colour-coding process and this does leave traces of its presence on the picture. This shows as an interference with fine picture detail. Component, by sending as the individual colours, eliminates this, but raises another problem.

We have seen how the final picture gets built up on the screen from a very precise mix of red, green and blue. Should the relative values of these three become altered, then the final colour will differ from the original. The three channels of component video have, therefore, to be very precisely matched. Additional complexity is now necessary for the three-way system. Composite video suffers from no such problems. It is a very robust method of transmission that, particularly in the European PAL, gives very good protection to the colour information.

The choice between the two arrangements depends on many factors. It is preferable to record signals in component form, as the recording process is quite demanding on a composite signal. It can easily exacerbate interaction between the chrominance and luminance, particularly where there are saturated colours. In an ideal world, component would be the answer. In practice, the accuracy needed to provide and then match, three circuits over long distances is much too expensive.

Accepting that composite gives greater security against distortion than component, a system that affords total protection from the dangers just referred to is digital. Either component or composite may be put into a digital form. This is a bit like sending off fine bone china; the better the packing, the less chance of damage. But what is the price of the packing?

## Television standards

There are two principal line standards in current use, the American/Japanese NTSC-525-line system and the European PAL 625-line system. The two standards use different Frame Rates: 30 times a second for the former, and 25 times a second for the latter. Pictures created in one standard are not reproducible in the other. This can only be done by standards conversion, a complex operation involving the

dismantling of the signal in one standard and reassembling in the other. It is thus liable to introduce distortions and errors in the process. As an aside, film has no such difficulty and for this reason is often used for international distribution.

## Video signal measurement

Video measurement is divided into two parts: the picture alone and the complete signal of picture and synchronizing information. As our principal concern is the picture, the implications of the whole signal will be covered when discussing specific situations. Picture measurement involves three principal parameters:

1. Exposure and contrast range.
2. Black level or pedestal.
3. Colour temperature.

These three will be discussed in more detail as part of specific situations, but brief descriptions follow.

Exposure is similar to that with film. The essential difference between film and video exposure measurement is that the latter, by producing an electronic signal of the scene, has the means to calculate its own exposure. Film has none of this and so the photographer's use of an exposure meter has become an essential discipline (and an accurate and reliable one too). The electronic camera is able to make the measurement but the photographer should be aware of how the camera does this and its effects upon the picture. The camera's calculation will be based on values in its own system. These may not correspond with those required for a particular scene.

Black level, often referred to as pedestal, is specific to video. The effect of black level change is best seen in a practical situation, but it may be described as changing the density values of picture black. In film terms it is base density or fog level. In fact, the equivalent film effect is to pre-flash or fog before or after exposure. The term pedestal is more of an engineering description and comes from observation of the effect when viewed as a waveform; the picture is seen to be lifted up above the waveform black level. Strictly speaking this means that black ceases to be black but moves to a value of grey. Different names are used to describe this: 'black', 'black level', 'pedestal' and 'lift'.

Adjustment of black level has become a very powerful and creative tool in picture manipulation. Such an easy operation is often used in television, where the darkest tone of the picture may be set just as required. This may be to make the darker tones lighter or darker. This, however, is a dangerous process, for if adjusted downwards too far, the greys will be reduced to black, losing all their gradation. If recorded or transmitted this way these tones will be lost forever.

Colour temperature has the same influence as in film; the red/blue shift in light when changing from tungsten filament lamps to daylight is discussed in a later chapter. Once again the electronic camera is able to

take care of this, being able to adjust itself to produce true grey and white. The camera will follow a predetermined calculation if this is what the photographer requires, or it may be overridden.

These three parameters are the basic video functions and as such are subject to pre-set camera parameters which will only be correct for a specific set of circumstances. The utilization of them or otherwise is a photographic decision.

## The picture

In Chapter 1 the influence of the camera on the receiver and vice versa was outlined with the problems associated with picture monitoring. Like the camera, the monitor has variables:

1. Brightness. This is similar to pedestal or lift being the monitor black level adjustment.
2. Contrast (sometimes called 'picture'). This is a similar effect to adjusting exposure on the camera.
3. Saturation. This is the amount of colour present.

Such a system that has similar picture-related variables at both the taking stage and the viewing stage is inherently unreliable, for there is no way to distinguish on the picture which is responsible for which. There has to be a means to intercept this problem.

## Using the waveform

We have so far discussed the waveform as a graphical representation of the picture and its associated synchronizing information. Waveform monitoring is the technique of observing the waveform for measurement.

*The waveform monitor*

The waveform monitor (WFM) displays the video signal in graphical form. It uses a spot of light that passes from left to right across the screen, taking a specific time to do so. As it passes it is deflected vertically to represent signal voltage. It has two principal modes of operation, 'line' and 'field', in 'line' mode it scans at line rate. i.e. all lines are shown superimposed over each other.

In 'field' mode all the lines of both fields are shown sequentially. They appears as the two fields, one after the other, which constitute a frame. The frame rate is 1/25 frames per second in PAL or 1/30 frames per second in NTSC.

WFM's are able to show all aspects of the waveform for technical purposes. They have the means to magnify parts of the display, to remove colour so that only luminance is shown, and to show only colour. The last is revealed as the colour subcarrier part of the waveform.

The waveform is displayed against a graticule from which measurements may be made.

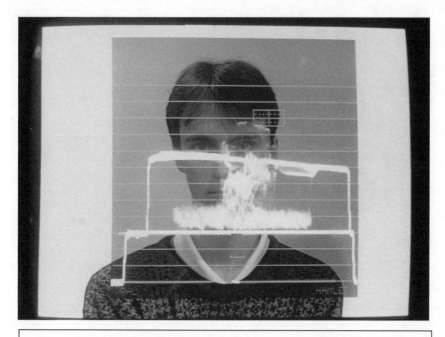

The waveform does not relate signal levels to the picture easily when this is a typical scene. The background is easy to spot at about 50 per cent but the all-important face is not. Note that presence of colour shows as a thickening of the trace. This is an indicator of the colour saturation. It does not indicate the hue

**Figure 2.6  Typical picture waveform**

The use of WFMs is as old as television itself and over the years has become established as the standard measurement system. To an engineer a WFM is essential to verify that the system functions correctly, from cameras to transmission chains. WFMs may be flexible enough in their design to enable circuitry fault finding.

We have the choice when using a WFM of displaying the signal in the form of all picture lines together, i.e. all overlaid, or as a complete frame (here the display actually shows all lines sequentially making both fields).

The display is placed against a scale, or graticule, from which measurements may be made of signal level.

Waveform monitoring also has value as a picture level indicator (rather like a VU meter for audio). Such is the popularity of this form of signal monitoring that it has found its way into many operational systems. This is particularly so where there is traditionally an engineering element, such as lighting and vision control rooms.

It is here that the value of waveform monitoring as a picture assessment system becomes limited. A graphical display takes considerable experience to interpret where pictures rather than test signals are concerned.

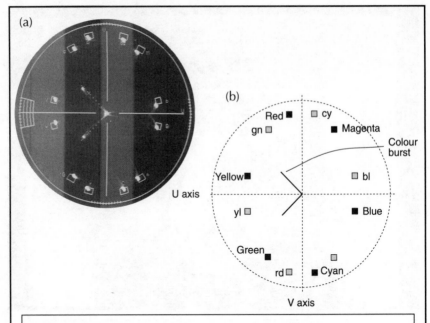

This displays only colour information. It shows the three primary colours and their complements as they are inserted, or encoded, into the video signal. This is shown by the position around the display. This is called 'colour phase'. As the vector display is a full circle, it can indicate any colour. It is also a logical display, complementary colours appearing opposite the associated primaries. Saturation is measured by how far the indicating spot is from the centre; the centre is 'no colour'. This is an 'in picture' display from the Hamlet Videoscope. (Courtesy Hamlet Video International.)

The vectorscope is a circular display that illustrates that the chrominance is held in the video signal as a phase, or vector, coded component. The colours are shown where they will appear at their maximum permitted amounts, as in colour bars. In PAL each has two positions, those shown with full labels and solid boxes, and another position vertically displaced. The latter are due to the PAL switching of the vertical  axis component every other line to offset the effects of phase error distortion in the transmission system. NTSC does not switch and only the principal colour positions will appear. Note also the colour burst. This appears as a horizontal 'V' in PAL, again due to the PAL switching. In NTSC, this is a single horizontal line. The two axes, U and V, are references used in the coding process. When colour is absent from the picture, only the colour burst will be present. With colour the display 'opens out' from the centre to indicate the amount or saturation

**Figure 2.7   The vector display and the vectorscope**

There is an inherent difficulty in relating the picture to the waveform, and this can be misleading. Excessive reliance on waveform monitoring in an operational situation is bad practice that can lead to picture estrangement where the waveform assumes greater importance than the picture.

Using the waveform to this degree can cause the more technically minded to place too great an emphasis on the graphical display rather than the picture itself. And it is, after all, pictures that we are creating.

It is in the traditional field of engineering that the WFM comes into its own. When dealing with test signals, or if analysis of the signal sync information is required, there is no alternative.

A new departure in this field is to display the waveform on a picture monitor (the waveform photographs are from this type of display). Very effective WFM can be undertaken without incurring the expense of a traditional waveform monitor. This development has the additional advantage of a large bright display that is most beneficial in less than perfect viewing conditions. The availability of picture and waveform being seen together is a further option.

*Vectorscope*

When colour came it brought with it even greater demands for measurement. The colour information, being embedded in the waveform in its envelope of subcarrier, was, of course, an important factor. It could be seen on the WFM but this did not show colour hue. To deal with this the vectorscope was introduced. This complements the WFM, they are usually installed together, the two together making the complete technical measurement system.

## Vical™

A more recent concept in operational measurement is the Vical system. This method is totally different to any other in that it is a purely visual technique. It works by creating a picture element that the eye can understand. There is no requirement for translation from a graphical display. It is entirely visual and was developed for the growing number of video users who do not have technical knowledge and have no desire to acquire it.

Because this system is picture based there is no distancing from the picture as there is with a WFM. The Vical bar may be used as a constant scene reference. The fundamental difference between Vical and waveform monitoring is the principle of inserting a visual reference into the picture as opposed to interpreting a graphical representation of the whole signal.

The systems of measurement described here are complementary and should always be seen in that way. Later chapters will detail specific uses for them as they arise.

Vical makes use of the eye's ability to compare side-by-side images very quickly and very accurately. The technique makes measurement of picture level and assessment of the trueness of grey an easy procedure. The video signal that feeds the picture monitor has added to it a picture element in the form of a vertical grey bar. To both monitor and eye the bar appears as part of the picture. Integrated in this way the bar becomes part of the picture and a reference against which real picture elements are easily compared. The bar is variable in level from black to white and, as this value is indicated on the instrument, there is provided the means to measure by comparison. The inserted bar is a calibrated test signal that is placed into the monitor picture and therefore appears as if it were part of the camera picture. The result is viewed on a standard picture monitor of whatever type the user chooses, allowing the eye to see the composite as one image. Monitor distortions (these may be apparent or not) that affect the picture also affect the inserted bar to exactly the same degree, but as the bar is a calibrated and a known reference it is still valid to compare the picture to the bar. The bar is also a colour reference for it is generated as pure grey; the camera interpretation of grey can now be seen to be correct or not. By adjustment of the bar to any value between black and white, the photographer can pre-set any tonal value into the picture, or the photographer may position it to lie against a specific picture element and thereby measure the value of that element by comparison

**Figure 2.8    The Vical method**

# Sending pictures

The familiar connections between the equipment are well known but there are important principles behind these video cables that protect our pictures. Their misuse can have the opposite effect. The signal appears as an output and is presented as an input; the two must therefore be compatible. The cable itself influences the signal it transmits and this was recognized in early development, such that measures were taken to offset the problem as far as was possible.

Two factors affect the signal when it is sent down a cable, cable construction and length. As regards the construction, it is important only to realize that video signals should be sent down cable specifically designed for that purpose. Other types of cable, such as that used for audio signals, may distort the signal unacceptably. The length of the cable is an important consideration. With a cable of 100 m, a loss, as it is called, will be experienced, but is easily corrected with the right equipment. For our purposes in the studio or on location such lengths are unlikely and the system is well able to work with good quality cable in lengths of tens of metres without our needing to be concerned about signal distortion.

Where video connections are made into and out of equipment, a special connector called a 'BNC' is used. The use of these connectors may be taken to indicate that a signal is present that conforms to international standards. Such a standard allows considerable flexibility of operation. One rule must always be observed; a source may only be connected to a single destination. A destination, on receiving a signal, draws power from the source; this is a fundamental aspect of the design, to make the transmission system as rugged as possible. To connect, say, two monitors to one output of a camera would give pictures of only half the brightness, for the signal would be divided between them. Each destination provides a proper termination to the signal. Such terminations are, again, an international standard.

The use of these standards is a great convenience but the limits must always be observed. The rear panels of video equipment may seem daunting, with labelling not always providing full information for the non-technical user. Here manufacturers differ in their terminology, an unfortunate situation that cries out for rationalization.

A very common exception to the rule is known as 'loop-through'. Here the normal termination condition is not present and therefore no power is drawn from the source. It allows the signal to feed more than one destination. Each destination 'observes' the signal as it passes, or loops through.

To make use of this facility, cable lengths between the destinations should not exceed 10 m, as otherwise distortions may occur. But the arrangement is ideal if we need to use two monitors near to each other. By allowing the signal to loop through the first monitor, and then to pass to the second where it will be terminated, only a single termination is experienced by the source video and all the requirements of the system are met. Both pictures

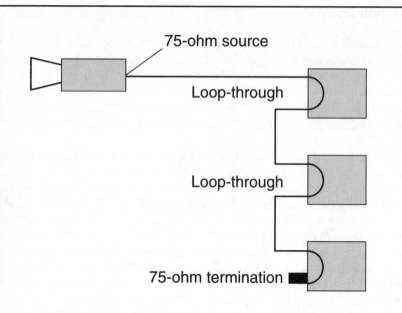

75-ohm source

Loop-through

Loop-through

75-ohm termination

The standard value of video termination is 75 ohms ($\Omega$). This pure resistance is a 'load' on the signal source. It thereby draws power from that source down the connecting cable. The cable has to be designed to carry that load without distortion. Video cable is accordingly rated to work at 75 $\Omega$. The circuit termination is conventionally placed at the input socket. The principle of one source, one destination must always be observed. But it is possible to overcome the inconvenience that this brings with appropriate equipment. This is done by 'looping-through' where a destination does not offer a termination, allowing the signal to pass on to another. For instance, a single source may feed a picture to more than one monitor. The last one in the chain must, however, provide the termination. Much equipment at a broadcast level offers this facility. Monitors are often provided with two BNC sockets at the input. These are paralleled together and either may be fed with the signal. The other feeds the signal on, or is fitted with a termination if this is not required or if it is the last of a chain. Terminations for this purpose are in the form of a blank BNC plug.

*Note.* If only one input socket is provided, loop-through is not possible. Also, this is only available where BNC connectors are provided

**Figure 2.9   Terminations**

will have their full brilliance and no distortion will occur. Not all equip-
ment makes the facility available, including many of the less expensive
monitors and receivers.

When looping-through, always ensure that at the end of the chain a sin-
gle termination exists.

In considering the sending of a signal from one piece of equipment to
another using standard interconnections, we must be mindful of the lim-
itations placed on that signal. The waveform shows the values of sync,
colour, black and white. The maximum value of white will, in practice,
depend upon the picture, but the maximum transmittable value is 100 per
cent, or peak white. Values that exceed 100 per cent will be removed by a
broadcast transmission system to ensure its own protection.

We shall consider the implications of this later.

# CHAPTER 3

# THE KIT: CAMERA AND MONITOR

The camera and monitor are principal elements of photography in video systems.

The interrelationship between the camera and the monitor is a perpetual problem, but not an insurmountable one. The background to this is fundamental to good video photography. The procedures involved in setting up monitor and camera are worked through later in the book. Before this, it is important to obtain a good understanding of all the controlling parameters.

Video is a system of variables; for those used to the formality of film operation, such a system often presents a frightening prospect. Many of the controls are powerful and, unfortunately, these are usually the most common. This situation is further compounded by the similarity of controls available on both camera and monitor. For this reason they will be dealt with together.

## Contrast and exposure

In theory the light entering the camera's lens should be replicated by the light emitted from the display screen. This fine ideal, like so many others in photography, cannot be achieved, as there are too many places where errors can arise. Determining exactly where errors occur may be very desirable to an engineer, who needs to have a complete knowledge of the whole system, but at an operational level a more simplified model may be used. It is sufficient only to place errors reliably at either camera or monitor, or both. To determine which of these is right and which is wrong is of paramount importance to the photographer.

The monitor is only able to produce as much light as its design allows. Also, it is only able to reproduce a black that is as dark as the screen. From this it follows that the best black that is achievable is controlled by how much ambient light falls onto the screen. In this respect, video displays based on the CRT have an advantage over film projection. Unfortunately, this advantage has been abused over the years.

A film projection screen is white, or at least highly reflective. The

darkest 'black' that can therefore be achieved depends entirely upon how much ambient light falls onto the screen. A television or monitor produces light; its screen does not have to be white to do so. The darker the screen can be made the darker the black available in our picture. This is done by using a non-reflective base. Because a television screen is a light emitter rather than a light reflector, it has become possible to view it in higher ambient lighting levels.

These lighting levels are in no way controlled by the photographer and so this advantage has turned into an unknown quantity. In the film theatre it is accepted that the lights are turned off, or at least dimmed to an acceptable level, before the programme starts. The photographer using video is immediately at a disadvantage; there is an unpredictable factor that must be taken into consideration at some point.

The maximum light available from the screen is entirely dependent on its design and efficiency as a light generator, so the two limits of the picture are black, determined by how much ambient light is reflected from the screen, and white, which is how much light the screen can produce. This is the contrast range of the television, or monitor, screen.

If the ambient light is high, the screen black rises to a higher level, reducing the effective contrast of the screen. The camera, however, produces the same range of tonal values regardless of this contrast distortion of the display. Such a situation makes assessment of the camera's picture unreliable. To complicate matters further, the monitor is provided with a contrast control of its own. This allows the screen light output to be altered. Turning up the contrast control makes the scene white values become brighter, effectively increasing the difference between black and white. It is now possible to raise the whole range to a higher set of values. The higher value for black is now, to some extent, compensated for by a higher value of white. The eye also makes a contribution by assuming that this new value for black means that white should therefore be at a particular level. This, as you can see, is rather arbitrary, and there is still more to come.

The camera has a contrast control too, called 'exposure', or light input. The lens iris controls the amount of light transmitted by the lens to the sensors such that the image tonal range can be brought within the video system limits of video black and peak white. But as we have already seen, these limits as displayed on our monitor are variable. The two controls, picture contrast and camera exposure are interdependent. We must have one correct before we can set the other. If we do not, the eye will attempt an answer of its own.

In a typical situation where a monitor is used on set or location to see the result of the photographer's efforts, this interaction is extremely important. Using a monitor in viewing conditions in which the two tonal extremes are false is of no value to the photographer at all in setting camera exposure or adjusting lighting. Nor is it of value to other interested parties, such as make-up artists, who want to see how effective their work is. It really has little more value than a framing aid; one assumes that the camera already has an adequate viewfinder provided for this purpose.

## Brightness and pedestal

In video there is another very powerful control that sets black level. The idea of being able to set the 'black level' of a scene is a contradiction in terms. Black is black, without light; to move from black is to become grey. But we must get used to using terms that are strictly incorrect, for electronics makes such variables available. It is up to the photographer to understand the implications of this valuable tool. It is now possible to make the scene blacks reproduce at a different value for entirely creative effects.

Television manufacturers also provide an identical control, this time called brightness. This control is intended to set the lowest scenic tone (picture black) so that it is just visible on the screen. Unlike the camera control of black, the display black must reproduce at a fixed level: that which corresponds to light extinction of the screen, no higher and no lower. By adjusting monitor brightness to this position we are able to see those tones, at or near black as determined by the camera. Once more the two controls, that in the camera and that on the monitor, will interact in that each may cancel the effect of the other.

Camera black level, often known as pedestal (and sometimes lift, or just black), allows the lowest video limit to be set. It has both technical and pictorial implications. The lowest limit must be defined technically, as it provides, for all parts of the system, a reliable base to which all picture processing can be referred. Black level was described in Chapter 2. In practice, the term divides into two parts: video black, or system black, and camera black, or picture black. It is the latter that is the variable, camera black level and monitor brightness both referring to picture black. System black is true video black and always remains operationally untouchable to ensure the system reference validity. But as the viewer only sees picture black this is all we need concern ourselves with, at least, at this stage.

If we adjust monitor brightness down, then we will see our picture gradually disappear into a black screen. The picture is now said to be crushed. The tones above black are progressively reduced to a black screen. The same can be done to the camera. But the difference is that the brightness control affects only the monitor picture, whereas camera black level affects the camera picture. The significance is that in the first case, the fault is limited to just one picture, whilst the other affects every picture.

The distinction between the two is obvious, but it is not uncommon for monitors to compensate for camera errors. Black level error is the most likely to occur, for setting monitor brightness is quite critical. It is relatively easy to have a camera black error not seen because the monitor has the opposite error. If the camera black has been adjusted down, i.e. it crushes out the darker greys to black, these tones will be lost forever: this may be compared to a condition of film where, due to errors in development, the lower range of scene tones are not fully resolved.

These are hazards of video pictures. Worse, they may pass unnoticed.

## A few practical considerations

Whenever a monitor is brought into use it attracts interest. All parties refer to it for their own craft purposes, or simply through interest. Seeing a picture in the presence of high ambient light gives a misleading result. All those using it, whether understanding the problem or not, will offer their own advice on how the picture should look. It will not be long before the monitor controls receive attention; however well intentioned, this is usually without the photographer knowing and is almost certainly not in the photographer's best interests. Nor is it unknown for the monitor to assume a god-like role drawing all to watch it. When this happens the result is usually counter-productive and the monitor is best dispensed with altogether.

It is very easy to place the monitor in a position that is convenient for yourself and others, but this may not be the best position for accurate viewing of the picture. Scene lighting may be too close or, the worst case of all, you may be outdoors in full daylight. It is important to shield the screen, but even here the ambient light may still be too high. Picture tubes are not able to produce the amount of light necessary to compete with daylight and there is the temptation to turn contrast to maximum and raise the brightness as well. The resulting extra demand now put on the system may exceed its ability, causing it to produce distorted tonal values and black errors.

Such a combination with the two variables is unreliable, and unless some means is provided to guarantee one of them quite disastrous results may result. It may not be readily admitted, but there have been many such situations where the location monitor has compensated for camera errors and allowed faulty pictures to be recorded. In most cases the operating conditions for the monitor are at fault; too high an ambient light is the most common, making it difficult to achieve correct monitor set-up. In Chapter 1 the interrelationship between the camera and monitor was described at length, with the importance of ensuring the correct operating conditions being emphasised.

In all this we assume a monitor is available. In fact, this is rarely the case. None the less a thorough check of camera and monitor to establish how well these are telling the truth about pictures is vital. It is important to always remain aware of the picture and how adjustments affect it; by treating camera and monitor as one, we aim to make a matched system. So, when these are later used separately, we should have the confidence in them to know that our pictures will be as we require. In the absence of a monitor we are left with the viewfinder. The inherent differences between these are monochrome image and monocular vision (unless a larger viewfinder is fitted). It is only experience that makes up for these. Chapter 7 discusses this problem.

## The complication of colour

The two colour parameters are saturation, or colour density, and hue. Of

the two, saturation is the most likely to vary, or come into question. It is the most easily changed by the camera – monitor interaction. Information about this is sent on the video signal in such a way that it is less well protected from distortion than hue. This is an important distinction; the eye is much more sensitive to hue changes than saturation and hence the emphasis on the former. Even so, saturation is important to get right and it is the monitor where variations are most likely to occur.

The maximum value of colour saturation permitted in video is that shown in camera colour bars (see Chapter 2). It is most unlikely that practical scene colours will approach the maximum as seen in colour bars. Complete desaturation of a colour is to remove all colour, rendering it to its monochrome value of grey. These represent the limits of colour saturation, and colours found in real life have values that lie between these limits.

The camera translates all scene colours into values of red, green and blue. These values together describe accurately the hue and saturation. The equivalent value of grey that comes out of this equation is the luminance value. This stems directly from the original requirement of colour television to be compatible with black and white television.

Let us consider the monitor and how it deals with saturation. We have seen that when all colours are at their maximum values, white will result from the screen. To correctly set the monitor saturation (here often labelled colour) can be difficult. Some monitors have the facility to select each colour singly (this is available in most receivers but will require access to the interior – not recommended to the uninitiated). If this is available, by choosing each colour in turn, we will see how the colour combinations are made. Note that the white bar now appears as the fully saturated colour in each case, illustrating the basic television rule that when all colours are equal, maximum white is produced. This rule is rather simplistic but the ease of mathematical calculation by electronics makes such things possible.

Once more we require the monitor to be above suspicion. Colour, like brightness and contrast, must have only one setting; the correct one. Such expectations are based on common tube characteristics. Indeed, these must match those of other display systems an ideal not always achieved in practice.

On the other hand, camera designers may deviate in their own particular way to enhance certain types of picture. It is a very similar position to that of film, where emulsions differ in response to user requirements. These variations are easier to see than measure in a practical situation. But since we are considering only one camera we may take its colour rendition as correct; in isolation we probably will not notice nuances of colour rendition. With more than one camera, however, this will become an important consideration.

The eye is extremely sensitive to slight differences in colour when displayed side by side or sequentially. Where a single camera's features will pass as acceptable, two working together will reveal their differences far too easily to be ignored.

Actual measurement of hue and saturation values of the camera is quite possible but normally only undertaken as part of a laboratory or workshop exercise. For this reason the adjustment of these is avoided as an operational control on the camera unless part of a larger studio system. After all, it is dangerous to disturb a parameter if we are unable to measure it and so restore it to its original value.

However, the monitor (and television) does have such a control available; called 'colour' on most television-based units and, more correctly, 'saturation' on professional monitors. The control usually has a range from zero, which is no colour, to some high value limited only by the electronics. Somewhere between the two is the correct value that has to be determined.

## Monitor line-up equipment

Setting up the camera and monitor must be methodical. This combination of overlapping variables is quite unreliable and unless some means is provided to measure these, quite disastrous results may result.

We could use a monitor line-up test signal generator to get the picture right first. Devices are available that generate accurate video signals for this purpose. But they are invariably intended for strict viewing conditions and are therefore limited to studio or vehicle-based systems. It is assumed that the correct lighting conditions are provided in studios and vehicle-based systems for monitor line-up facilities to be used properly. For these more permanent installations it is easy to provide picture line-up equipment, but for film-style, single-camera operation this will add a degree of complication many would rather avoid.

To use this device will involve separating the camera from the monitor, setting up the latter with the picture set-up facility, and reconnecting back to the camera. And there is a further unknown; the signals from camera and the test generator have to be similar if the test is to be valid. In practice, the degree of accuracy required, particularly at black level, may cause errors here. Discrepancies may, therefore, arise due to mismatch of the two signals. Despite the limitations, these devices are occasionally seen in the field.

## Using a waveform monitor (WFM)

A WFM will check the camera. It will require the user to interpret the waveform to know how to adjust the camera, but this is the traditional approach. This WFM is unable to set up the monitor directly. But by allowing exposure and black level to be set at the camera, producing a picture correctly between the limits of black and white, the monitor can be set to reproduce this picture with reasonable confidence. But how do we interpret the waveform to do this reliably? This does require experience

and if this is limited then the value of WFM is limited also. The WFM is essentially an engineering device. It is able to indicate a very great deal about the performance of the camera and how it is set up in engineering terms. But we require an operational procedure with a picture-based outcome, and waveform monitoring is rather too cumbersome for this to be completely successful.

The camera's own test signal, colour bars, is a useful aid. It is a guaranteed signal that can be displayed on the monitor. The extreme right-hand edge has a black bar, allowing monitor brightness to be set up. But this will be inaccurate, for the black bar is small and displayed in the presence of the other full colour bars, making correct setting of brightness difficult to get right. This usually results in setting the monitor brightness too high.

The white bar on the left-hand edge is the maximum level permitted. It does nothing to tell us how well the monitor performs at this level.

Colour bars only prove that the monitor is able to display a picture; they provide little assistance in setting it up correctly. They are, at least, a consistent signal to feed the monitor.

There is, of course, no reason why combinations of all the above techniques should not be used. This has been accepted practice in studio and other permanent installations, although it is rather cumbersome. For the single operator requiring simple and quick results, it is unacceptable.

The camera manufacturer is also aware of this problem and has already taken one step towards an answer – to make unavailable the camera controls. The black level control can be out of reach, inside the body of the camera, pre-set at the factory. Exposure can be automatic, just as many stills cameras are. The photographer now has to rely entirely on the camera and its designer.

Colour can be automated too. By leaving the control of all these parameters to the camera designer, we forego the ability to control them ourselves. And the designer assumes the role of knowing what the photographer wants. This may be a successful option for the inexperienced amateur, but is usually not able to produce what the professional demands.

## A new approach to measurement

A development that came about directly as a result of the above difficulties of early single-camera operation is Vical (see Chapter 2). Vical distinguishes between camera and monitor problems by taking the picture from the camera and adding to it a known visual element determined by the photographer. The monitor displays this element as if it were part of the scene the camera is pointed at. This known signal, placed onto the camera's own picture, appears to both monitor and eye as one entity. The signal added is simple and easily interpreted. By using this principle, Vical facilitates both monitor and camera set-up in one operation.

This simple system is designed for field operation; it provides the ease

and speed required and the confidence that comes from checking out the two component parts but retaining the philosophy of the ideal photographic system, control of camera and display. The simplicity avoids the technical side completely. It does not, therefore, provide the full measurement capability of waveform monitoring, something rarely required in the field.

The practical procedures in later chapters make use of these techniques of set-up and measurement. Each has merits and limitations and these will be brought out as they become appropriate. But in all cases the intention and outcome must be the same; to give sufficient confidence to shoot reliably. When this is point is reached, video may be shot in the same way as film.

# CHAPTER 4

# LENSES

The lens is the eye of the camera that makes the picture. There is already a great deal written on lenses but it is worthwhile discussing some of the practical aspects of lens design and performance that are specific to video. Lens design divides into two; the smaller ones used on lightweight cameras and the larger studio lenses. Here we shall look at the former.

Weight is a very significant part of camera design. Lenses have, over the years, become more versatile, with wide zoom ranges and large apertures. Both of these require large and complex optics. To a lens designer, large aperture and long focal length are not complementary in that both require large optics and, when asked for together, the optics can become very large. Glass is heavy, and in a complex lens, with a large number of elements, rigidity becomes very important. We can see how good lenses tend to be big and heavy. Making them small, to fit the needs of small cameras, inevitably means compromise and it is important to know how this affects your photography.

Zoom lenses have been with us for many years and so their design follows established paths. Computer-aided design has been invaluable in making possible lenses of good performance at reasonable cost. But as improvements are made in resolution and contrast, we may also find other factors being traded in favour of weight and size. There is also the need to consider automatic and remote operation. So many pressures are on the designer to make improvements, and not always in the interests of better optics.

## Focal length

It is rare in video to see a prime lens. This is a lens of fixed focal length chosen for its optical performance. The zoom, a lens of variable focal length, is now almost universal; its convenience saves the cost of and the need to carry a set of fixed lenses, and also the time taken in changing them. In many cases a single zoom will do all the work required but a measure of operational compromise may be experienced and two zooms of different focal ranges may be used to make up the complete optical requirement.

Focal length indicates the picture angle of the lens. Angle is a better term to use for, unlike focal length, it is independent of the image size. The larger the camera's sensor, the larger the image size, or format, and the larger the lens; a ⅔-inch CCD will require a longer focal length lens than a ½-inch CCD camera for the same picture angle. The size of CCD chips is decided by technical factors but there is good reason to keep it as small as possible; a small format means a smaller lens. But, as with film, the larger the format, the better the picture.

There is a wide selection of zoom ranges available, from 5:1 right through to the 30:1 lenses of outside broadcast sport. A focal length of 10:1 means that the lens angle varies by 10:1. The greater the range the more operationally convenient, but the greater the optical compromise that may have to be accepted.

## Aperture and f-number

This is a measure of how much light the lens can pass. All lenses have a limit determined by the size of the optics. By taking a simple lens one can

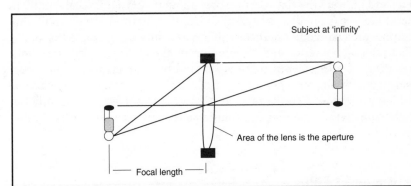

The larger the lens, the better the light-gathering power. The f-stop is the measure of this.

$$\frac{\text{Focal length, mm}}{\text{Diameter of the lens, mm}} = \text{f-stop number}$$

This is the relationship of focal length, the diameter and f-number of a simple lens. Note how, as the diameter of the lens increases, the f-number becomes smaller. The f-number relates to the aperture of a lens and indicates its effective light gathering power.

A larger image requires more light than a small one to achieve the same level of brightness. Hence larger image formats demand larger lenses. Ths brightness of the image translates into film or sensor exposure.

**Figure 4.1   Lens and aperture**

easily realize that the larger it is, the brighter will be the image. It is a question of the area. The light transmitted is proportional to the area of the lens. The name given to this is aperture.

The f-number is a direct indicator of the amount of light a lens will pass, or transmit. The smaller this figure is, the higher the transmission. Taking the simple illustration in Figure 4.1, by increasing the diameter of the lens it is able to collect more light from the subject and focus it onto the receptors. This relationship applies to all lenses. From it you can see why a long focus lens is longer and proportionally larger in diameter.

The relationship of focal length, lens diameter and f-number states that if the focal length is changed then so will the f-number, assuming the lens diameter remains the same. For example, zooming in (increasing the focal length) raises the f-number and the light transmitted falls. We would expect; therefore, the exposure to fall as this happens: an unfortunate situation were it not for the fact that it is compensated for. But there is a penalty.

The law relating focal length, aperture and f-number is a physical property, and cannot be changed. The designer gets around aperture changing in a zoom lens by: (1) reducing the effective aperture to a more practical value; and (2) tracking the aperture or making it vary with focal length. In practical lenses of smaller range, say 2:1, similar to those used in still photography, the change in aperture will theoretically vary by a factor of 2.

This change of aperture is compensated for by varying amounts, depending on design. But there is invariably an aperture, or f-number penalty, which shows when comparing size for size fixed and variable focal length lenses of similar size and weight. The fixed lens usually has an aperture twice (one f-stop) as large as that of a zoom lens of similar size.

## The iris and f-stops

Camera lenses make use of variable aperture to control the amount of light entering the system. This function is carried out by the iris, an arrangement of metal blades forming a circular opening that opens and closes. The control operating the iris is the ring on the lens barrel marked in f-numbers, often called f-stops. As the ring is rotated, so we change the lens aperture as indicated on the scale. At one end is the lowest figure corresponding to the maximum aperture of the lens. There may be two figures here; these are the two aperture values corresponding to the extremes of the zoom range.

The f-numbers relate back to the light-gathering power of the lens, which is related to the area of the lens. In the case of a complex optic such as a camera lens, this does not mean the diameter of the front element, although this is an indicator. Actual dimensions vary from lens to lens, type by type. To make possible the comparison of light-gathering between one lens and another, the f-number system is used. This takes into account

the focal length of the lens and its design. An f2.0 lens of 10 mm will have the same light-gathering power as an f2.0 lens of 100 mm. Both will give the same exposure. The iris ring is calibrated in f-stops, as shown in the following example:

| | | | | | | | | |
|---|---|---|---|---|---|---|---|---|
| *f-stop* | 1.4 | 2.0 | 2.8 | 4 | 5.6 | 8 | 11 | 16 | 22 |
| | ⇐ | ⇐ OPENING ⇐ | | | **IRIS** | ⇒ CLOSING ⇒ | | ⇒ |

Note the sequence changes by a factor of $\sqrt{2}$, which is 1.414. Each iris click increases the diameter of the opening by this amount.

Increasing the number reduces the light passing; this is often called stopping the lens down. In the opposite direction, opening the lens allows more light to pass, and the stop number reduces. Moving one number is one f-stop and, depending on whether the iris opens or closes, halves or doubles the amount of light passing.

## Iris ramping

Many wide-range zoom lenses reduce aperture quite markedly as they approach the maximum focal length. This is iris ramping. It occurs when the lens is working at a wider aperture. As the lens zooms in, the focal length increases, and the lens hits the combined limit imposed by aperture and focal length; the aperture suddenly ramps down, reducing exposure. This is a design compromise where size, weight and price together tip the balance over performance. A zoom limit option is provided on some studio lenses that restricts the maximum focal length to that available for a constant aperture.

## Zoom range and aperture

Zoom lenses are often fitted with a range extender. This allows the user to shift the lens range to another value; for example, a lens of focal length 9–135 mm with a 2× extender will become 18–270 mm. There is an aperture penalty; if the original was stated as f1.4, then using the extender will reduce this to f2.8. Thus the exposure reduces by four times, or two f-stops. The formula relating f-number, aperture and focal length determines this.

A lens described as 15 × 9 has a minimum focal length of 9 mm and a zoom range of times 15. The maximum focal length is therefore 15 × 9 mm = 135 mm. A 2× extender makes this 15 × 18 mm = 270 mm. A 1.4× extender gives an extended range of 15 × 12.6 mm = 189 mm. The 1.4× extender halves the exposure (reduces it by one f-stop).

## Zoom angle

Lens, or picture angle, and focal length are directly related by the image size, or format size.

For a ⅔-inch format the focal length and angle are:

| Focal length (mm) | 9 | 18 | 36 | 72 | 144 | 288 |
|---|---|---|---|---|---|---|
| Horizontal viewing angle degrees | 52 | 26 | 13 | 6.5 | 3.25 | 1.63 |

If a ½-inch format is used, then to achieve the above viewing angles the focal length will be: 6, 12, 24, 48, 96, and 192 respectively. The above figures are a guide only; in practice the actual values will depend on individual lens design.

The lens for ½-inch operation will be correspondingly smaller than its ⅔-inch counterpart.

Whilst on the subject of viewing angle, there is one point to bear in mind. It is the horizontal angle that is the most useful to us in picture terms. However, a lens is a circular object and accepts a solid conical angle of light. To the lens, therefore, 'horizontal' is meaningless, for its limits are determined by its diameter. Thus the lens designer may quote a figure that is the corner-to-corner angle, the diagonal. This is the 'field' of the lens.

The standard aspect ratio of video and television is 4 : 3; dividing the field angle by 1.25 will give the horizontal viewing angle for video. For wider formats the horizontal angle will approach the field of the lens.

## Format sizes

All the above has influenced the format size very considerably. Photography started with large formats but, as technology and the understanding of it have improved, smaller and smaller formats have come into common usage. There are two main influences: resolution and convenience.

Resolution of the light-sensitive material has always been the limiting factor for image size. Each system, whether silver or silicon based, has a given number of pixels per unit area. If, therefore, we make the image smaller we have less pixels available. At the other end of the chain, our viewing display size determines whether the image pixel count will be seen or not. These inter-relations have already been discussed. The ideal, of course, is to use only sufficient imaging size as is required to fulfil the display requirement. Then the format size is kept to a minimum, with lens size and, ultimately, camera size.

## Depth of field and hyperfocal distance

Depth of field is the distance, or depth of the shot, that is in focus. It is a variable function and depends on three things:

1. Format size. The smaller the format (image size), the greater the depth of field.
2. Lens angle. As focal length decreases (zooming out), the depth of field increases.

3. Lens aperture. The smaller the aperture (lens stopped down).The greater the depth of field increases.

Video cameras have small formats, similar to 16-mm film, and have an inherently large depth of field. This factor is also aided artificially by the camera's detail processing. This tends to exaggerate sharp detail, giving the impression of good focus over a wide range. The use of depth of field as a photographic tool to emphasize or diminish scenic elements is therefore limited in video to shots of narrower angle.

On the other hand, a very wide-angle shot may well have a depth of field from infinity to within centimetres of the lens front element if the iris is well stopped down.

There has been a tendency to increase apertures of video lenses to reduce depth of field so that this may be used as a creative tool.

Depth of field is a very powerful creative tool. As such it is used to draw attention to elements of the picture by bringing them into sharp focus whilst softening others. Thus, it is possible to achieve emphasis and selection of parts of the picture depending on individual depths into the scene. The effect is varied by the lens aperture. Higher f-numbers have extended depth of field, the lower ones having reduced depth of field.

Lens aperture is not simply a means of controlling light, its control over depth of field is of the utmost importance to creative photography. Hyperfocal distance is useful in wide-angle work. It is where the depth of field is from infinity down to a minimum distance. This varies with aperture, but a point may be determined for any lens, and when it is set to this distance, the depth of field range includes infinity. Zoom lenses are not normally marked with a depth of field scale, but tables of depth of field should be available.

Regardless of the type or design of lens, these are facts governed by the the laws of physics. If the lens has a focal length of 9 mm with a subject at infinity focused onto the camera CCD sensor, the image will appear as though projected from a lens plane 9 mm in front of it. This plane is at the rear nodal point. As the lens zooms in and the focal length increases, the rear plane moves forward by the same amount.

The same argument applies in front of the lens. Here the actual position of the front plane becomes of more practical interest to the photographer. As a camera pans across a subject we will see a perspective distortion take place, and foreground and background will move relative to each other. However, if the camera is pivoted on the front plane, no such distortion occurs. The front plane lies at the front nodal point. This is the reason why early (and large) television cameras had their lenses set as far back as possible to bring the front plane nearer to the panning pivot (it also made them more compact).

Zooming in to a narrow angle causes the front plane to move forward well in front of the front element. If the plane moves over the panning point then the relative movement of foreground and background with panning will reverse as it crosses the pivot.

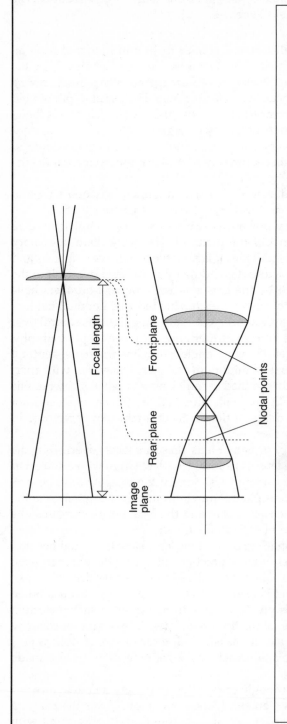

A simple lens has shortcomings which the complex lens is designed to correct. The simple lens has one reference plane that coincides with the lens. In a complex lens the lens plane splits into two. These are apparent planes, one that relates to the subject, and the other to the image. It is from the forward plane that the scene perspective is determined. From the rear plane the image is projected onto the image plane. At the centre of the reference planes are the nodal points. If the camera is pivoted at its forward nodal point, there will be no relative movement between foreground and background. Actual position of the nodal points is determined by lens design. They may lie outside the physical boundaries of the lens

**Figure 4.2   Nodal points**

# Back focus

The distance from the rear plane to the sensor is the back focal length. It is of importance because, in a 3× CCD video camera, this distance is very long to accommodate the splitter block. An interchangeable zoom lens will usually have the facility to adjust back focus to suit each individual camera.

The standard way of checking back focus is to set the camera up to look at a subject that has sufficient detail to focus on. This should be set at the distance laid down by either camera or lens manufacturer. Failing such information, use a distance of between 3 m and 5 m. Make sure there is only sufficient light to expose with the lens iris fully open to reduce the depth of field. Finding focus will now be much more precise.

Zoom in to narrow angle, and focus in the normal way. Then zoom out to wide angle; the image should remain sharp. If not, adjust the back focus until it is sharp. Repeat the procedure until focus holds evenly from one end of the lens to the other. This procedure will not normally be necessary unless the lens has been adjusted for use on another camera.

If there is the opportunity, check that the lens focuses at infinity at its narrowest angle. Infinity focusing need not be at true infinity (infinity is imaginary). Practical values of 'infinity' depend on individual circumstances. It could be the horizon for outside broadcasts, or across the studio if that is your boundary. Be aware, though, that you do not need to take the camera outside. In practice, with a standard zoom lens, a few hundred metres is ample.

This quick check of the lens will prove correct operation of lens and camera quite effectively. If any of the checks are still inconclusive after repeating them, consider having the lens checked out by an expert. A lens may become misaligned internally and the ability to hold focus reliably through the whole range is often the first indication of damage or wear.

# Close focus

One of the features available on modern zoom lenses is a close focus facility. An adapter swings into the light path at the rear of the lens and converts the focusing range; this is often known as macro. As the lens-to-subject distance is reduced, the effective aperture also reduces. So for the same exposure more light will be required on the subject. A further feature will be reduced depth of field.

Close focus is an additional feature which is secondary to the normal zoom lens function, and may result in other limiting factors. It is worth checking the performance of the lens to ascertain its close focus properties. Look for geometric distortion of the image, darkening in the corners, or vignetting, and softening of the image towards the edges.

# Plane of focus

It is not always appreciated that a lens may be unable to focus evenly over

a flat subject. For example, the centre may be in focus whilst the edges may not. This is an effect that depends on such things as working aperture, focal length and subject-to-lens distance. Most practical situations will never put the condition to the test, but nevertheless it is worth knowing about.

If it is required to photograph a flat surface, choose the best conditions for the camera and lens and, if possible, confirm these beforehand. The ideal operating condition for a lens would avoid extremes, so aim for the following:

1.  Use the centre part of the zoom range.
2.  Avoid close focusing. Choose a lens-to-subject distance of at least 1 m.
3.  Expose to achieve an f-stop between f4 to f11.

## Distortions

The most common geometric distortions are 'barrel' and 'pincushion'. In most situations these will not emerge as problems, as average subjects are not likely to reveal them. It is only when showing geometric forms, such as straight horizontal or vertical lines, that distortion may become apparent. The effects may be seen to vary with zoom angle, and sometimes even to change over as the lens goes from one extreme to the other.

Another form of distortion that may be seen when working a lens at a narrow angle is the difference in out-of-focus effect either side of focus. As the lens goes through focus the image will be defocused, then in focus, and then defocused again. The two defocused images may differ in

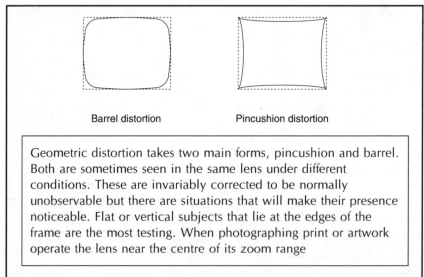

Barrel distortion                    Pincushion distortion

Geometric distortion takes two main forms, pincushion and barrel. Both are sometimes seen in the same lens under different conditions. These are invariably corrected to be normally unobservable but there are situations that will make their presence noticeable. Flat or vertical subjects that lie at the edges of the frame are the most testing. When photographing print or artwork operate the lens near the centre of its zoom range

**Figure 4.3   Geometric distortion**

appearance. This effect is not particular to video lenses but, due to the special requirements of video, often appears to be so. It is worth bearing in mind that a shot using differential focus may be improved if the out-of-focus image is moved to the other side of focus, if that is possible.

Such distortions have been features of the longer zoom range lenses used in video but as lens design improves overall they are less likely to be noticed.

## Shading the lens

All lenses must be protected from extraneous light, i.e. light not elemental to the scene in the frame. Any other light entering the lens has to be got rid of. If not, it will scatter within the lens and eventually find its way to the image. The result is flare and is particularly noticeable in the darker tones of the picture, where it lightens and spoils the carefully conceived tonal values.

Flare takes two forms: an image of the internal structure of the lens, usually the iris shape; or an overall lightening of the whole picture. Lens designers take great pains to control flare by coating the glass surfaces to reduce reflections and introducing internal baffling to control stray rays of light.

Zoom lenses are inherently more prone to flare than a lens of fixed focus because of the large number of elements used in their construction. A reflection occurs whenever light passes through a glass-to-air boundary. A molecular coating on the glass surface reduces this significantly. Such treatment is vital for the control of light scatter but it can never be a 100 per cent cure. In fact, the measure of reflectance is in percentage. If, say, a surface transmits 99 per cent of the light, 1 per cent will be reflected. This is a good performance, but if that surface is subject to the full power of the sun, or a lamp pointing directly into the lens, this 1 per cent can be considerable and may compete with the desired picture. Of course, this is an extreme case, but multiply this by the number of elements in a lens and you will see the magnitude of the problem.

Compounding the problem further, a zoom lens has moving elements that make ideal baffling more difficult to achieve. This is why moving flare is often seen as a lens zooms in or out. A large front element makes shading the lens more difficult, as the shade has to be well forward to be effective and still remain out of shot.

Setting aside the aesthetic or fashionable values that are often attached to lens flare, we must possess the means to control it. It is, after all, a mechanical artefact and not always appropriate. The common lens hood, or shade, that is supplied with the lens is usually ineffective. These serve a much more valuable purpose, helping to keep fingers and other lens-dirtying objects from the glass. The answer is to use a matte box.

The matte box places around the frame in front of the lens a black form, or matte. Any light outside the frame is therefore baffled before reaching

the lens. The box is coated to be internally non-reflective to light.

Practical matte boxes also suffer from limitations. Size alone makes effective control at all angles of the lens difficult. They are therefore often fitted for their ability to hold filters than to control stray light. Those possessing the additional facility of a flag are worthwhile. As most flare comes from above the lens, this simple arrangement on the top of the box is very useful.

The best solution is to avoid stray light in the first case. Try to work lamps away from the lens. Flag lamps that face the camera so that a shadow is cast where the lens is. A useful trick is to hold a clipboard just to shadow the lens during a take.

If a flare cannot be avoided, endeavour to make it as uniform over the whole frame as possible. Then, if the opportunity is offered later, this may be corrected, if only partially, by adjusting black level when replaying the tape. This is unfortunate if this happens to be live television.

## Filters

Filters constitute a subject that has occupied many writers on photography. It is not intended to cover this subject other than where video is particularly affected. It would benefit all photographers to study the subject well, to read about it and to make their own practical experiments to test what has been written.

Filtration is a two-part subject, the two parts being correction and effect. The former includes colour correction (see Chapter 6) and the latter creative modification. There are also those filters that could be said to fall into both camps. Contrast control filters may be used creatively. Indeed, it is not uncommon to see where colour correction filters have been successfully used for pictorial effect. Filters that produce star burst effects are definitely creative, and their value depends entirely on how appropriate they are in a particular situation.

The first thing to consider is how video differs from film, for it was for film that many filter techniques were invented. Chapter 2 sets out many of the features of video but specific points that affect how well filters perform are set out here.

The small format and video enhancement make for a large depth of field. This causes subjects quite close to the lens to be in focus, or very near so. A filter placed in the conventional position, i.e. in a matte box, may well be seen for what it is. The first rule of filters is, never be seen. Only the effect should be evident.

The latter point about being in focus has been tackled in another way: placing the filter behind the lens. This is a traditional place for corrective filters that are integral to the system, used for many years in stills, film movies and television. It has many advantages. The filter position is at an out-of-focus part of the light path, it will usually be enclosed and clean and, most important, the filter will be shaded from extraneous light. Another

practical advantage is the size of the filter. Behind-the-lens types are invariably smaller as the light approaches the imaging position.

Some filters are particularly suitable for placing behind the lens. Effects filters, such as fog and diffusion and those of the star burst family, suffer badly from extraneous light. These can work exceptionally well here. But there is one serious disadvantage; changing the filter, or rotating it to get the right effect, is not easy. Studio cameras have a filter wheel that is usually equipped with a set of filters in common usage, but this does not allow rotation of the filter.

Lightweight cameras only have one or two colour corrective filters permanently installed.

It is the very wide diversity of filters that a modern photographer needs that makes the front-of-lens operation the only option. This provides, above all, flexibility. The disadvantages of size, stray light, and protection from damage and dirt are all subordinate to this requirement.

## Cleaning and care of the lens

Lenses are both delicate and vulnerable. It goes without saying that they should be protected. Despite this, one still sees cameras being put away without lens caps. How significant it is that there are optics built a century ago that have less scratches than many modern television lens. Much of this is a discipline problem, not a lens cap problem.

Cleaning is part of the care. The front element is the most likely to get dirty or damaged, and keeping it covered when not in use will mostly avoid this. The back element is protected in use and only vulnerable when the lens is being changed. When the lens is removed you will see the camera filter wheel (or the splitter block or sensor chip). This should also be clean.

Scratches and dirt cause flares, and the action of cleaning can itself cause more damage if not done correctly. Use lens tissue only. Do not use household, industrial or handkerchief tissue, for all of these will scratch. A lens cloth or well-washed linen handkerchief is also good, but make sure that they are fresh and clean. These items are fine until they become dirty.

If dust is present, use a clean lens brush, or blow the dust away. A very useful tool is a can of pressurized air. Take care not to direct it at delicate parts, for the jet can be very powerful in a confined place. Also, hold the can level. When the dust is removed, grease or contamination can then be tackled with a tissue. The use of fluid is debatable. Some lens manufacturers do not recommend this. Breathing on the lens provides moisture that, with the tissue, helps to push grease away. But this is a personal matter for the individual to decide upon.

The lens shows up the presence of foreign matter easily, for the anti-reflective property of the coating is spoiled. It may only be a minute

amount. Before you subject the lens to a vigorous onslaught, consider whether it is best left until later.

Lens cleaning is a risky business. It is much better not to let the lens get dirty in the first place.

One way is to fit a permanent filter on the front element. This is highly recommended and will remove the fear of expensive front element damage. In most cases, a UV (ultraviolet) filter will not affect the lens performance, but there may a slight change of focus. Wide-angle lenses may be affected at the edges of the picture, with a slight softening. The filter mount may also show in the corners of the frame.

# CHAPTER 5

# LOOKING AT PICTURES

The objective is the picture. Does it tell the right story? Does it do the job? A fine picture may do neither.

## The eye

The eye is often compared to a camera. This analogy is flawed. In the first case, the eye is optically quite poor. It has a very basic lens, a sensor that is not uniform and, worst of all, a performance that is not constant. But to the average human that is no great problem, for the eye is an integral part of an information processor of immense power and intelligence. Cameras are now used in the most difficult of situations but have produced useful results simply because they have been given the assistance of computer processing. So the eye is perfectly in tune with this modern technology.

The eye is the photographer's livelihood and downfall. Before photography man hunted for his living and so our eyes and brain evolved accordingly. The art of making pictures is a new skill and so our eyes must be retrained. Photography is not catching food by hunting but by making pictures. This comes with learning, practice and experience. We practise the art of seeing as our camera sees by analysing our results, and understanding aesthetics and realising emotions. These human features cause reactions to stimuli, whether they be visual, aural, or physical. The photographer's skill is visual.

## Exposure

The eye will deceive whenever it sees what it considers is not wanted. Take its exposure system. There is the mechanical one, the iris. This is auto-exposure at a basic level. After this is the processor control that enables the same system to operate over an enormous range of light level. The average eye will work from about one lux (dusk light) upwards. The only restriction is that the eye has to acclimatize to changes that exceed the range of its iris. The rate at which the iris adjusts is quite fast; pre-flash

from a stills camera causes the eye's iris to stop down in a fraction of a second to avoid the camera seeing the red retina.

The gradual adjustment of the brain is more subtle. It is this that confuses us when we try to estimate light levels without a meter. Some can do it better than others, and this is another feature that adds to the confusion. Each person has different responses and sensitivities.

The exposure problem also emerges when setting up a monitor. It is very difficult to estimate its light output by eye. Again, some people are more adept at this than others, something that is not just a question of training and experience.

## Persistence

The eye's reaction to movement is quite slow. Movie projection and video both rely on this feature to blur a succession of discrete images into a coherent flowing moving image. This is persistence of vision.

Television images run at 25 frames per second in Europe (30 in America and Japan). Film projection runs at 24 frames per second. The eye does not see the changes of one frame to the next in the prime area of the retina in the centre. Whenever we look away from the screen, i.e. allowing the surrounding part from the retina to 'see' the screen, a flicker becomes evident. Also, as the brightness of the screen increases, so the chance of flicker becomes noticeably greater.

As light falls, persistence of vision becomes greater still. The extended exposure required under these conditions makes the eye response very slow. At night the effect may make movement not observable at all.

## Colour

Colour vision is another very individual condition. Some people do not see colour at all, a condition usually present from birth. Everyone sees colour differently to some degree or other. It is possible to match the colour response of individuals against a standard. The accuracy of such tests is good enough to find serious differences from the norm, but such is the acuteness of the eye in detecting colour differences that no two people will see exactly the same colour.

The eye is a three-colour sensor. We know that using red, green and blue inputs to the eye produces grey (grey is defined as no-colour, and white and black are the extremes of grey). You can prove this to yourself by using three lights of these colours. Point them at a white card, and then adjust the individual brightness carefully until the card shows white. Now ask someone else to adjust the lamps for their impression of grey. The result may be interesting. If their settings differ from yours, please do not think you are right and they are wrong. This can be a very critical test.

The ability to estimate light levels and colour is very unpredictable,

and is complicated even further by a dependence on our physical and mental states; tiredness can affect our vision.

Notice also how the eye 'white balances' perfectly; daylight and artificial light never look odd. Until, that is, they are photographed. In fact, the advent of colour photography has changed our perception of colour. Why do we use light with a warm reddish cast to light up windows for night exteriors? Why are night exteriors shot with a blue light? The answer can be found in experience of the visual arts, particularly cinema.

We now see complete programmes shot with a colour cast to give some visual 'feel' to the work. This may be orange-red, creating a warm and comfortable feeling. But why are whole scenes shot with a colour cast when the eye will eventually white balance this out?

Well, the human eye is still not fully understood. Its reaction obviously differs from person to person. Its acuteness is in seeing differences; overall colour casts balance out. However, as we become more educated and experienced at seeing pictures, this latter function becomes less effective. As picture-makers we develop the ability to suppress many of the automatic visual functions.

This education is being passed onto our viewers as well. They are much more aware of visual ploys than they were, say, 50 years ago. To answer the question: 'why shoot with a colour cast?', only throws up the question: 'how experienced is the audience?'

## Stereoscopic vision

Two eyes are better than one, but how much better? As there are two related inputs, we might say twice as good. With both eyes producing similar, but not identical, information, the brain is able to compute distance accurately – at least up to, say, 3–4 m. Beyond this distance it is only experience that says how far away the object is.

Consider the viewing screens currently in use. A large cinema screen is further away than we can easily measure by stereoscopy. Although not a stereo picture, it is more easily accepted as being real, for any portrayal of distance in the scene is less likely to be declared false, whereas the small television screen lies within this limit and is subject to much more strict analysis.

## Making pictures

The first question a photographer has to ask is 'What is the purpose of this picture?' A picture, whether still or moving, cannot be created successfully without some purpose behind it. Even the simple action of taking a snapshot has a purpose. The success of a picture hangs on how well it fulfils that purpose.

In pure photographic terms there is no distinction between moving and

still images. Each has its own visual expectations and its own particular craft skills.

Most of us take photographs to show to other people. We have all, at some time, handed out photos for our friends to see, usually in a very casual way and probably in shot order, just as they came out of the camera. This is probably quite a comfortable way to present them, as it tells something about our thoughts at the time. These thoughts might have been subconscious or conscious – in either case, if the order of the pictures is changed, the story is lost.

## The sequence: thinking about editing

Even a single framed picture on a wall is part of a sequence. It is part of the environment in which it hangs. The success of such a picture lies in its ability to fit into and become part of existing environments.

Video is a sequence of pictures. Shot by shot these are cut together to make a programme. Each shot must build on the previous one, or relate to it in some way. This editing task is a separate skill but we cannot create shots of our own choosing without the knowledge clearly in our mind of how the final putting together will happen.

In a real situation a movie is rarely made in story order. There are usually too many practical difficulties for this to happen. This is quite a severe test for those producing it. The first hurdle is that tackled by the storyteller, the scriptwriter. The actual writing is not the hurdle, but the communication of it to those destined to make it into a movie. Each specialist, from photographer to sound engineer, to editor, must understand the story, so that they can interpret it with their own skills. We must then take the sequence, disassemble it and make the pictures fit the final plan. A graphical representation called a storyboard is often used so that every shot is described.

Of course, there may be occasions when there will be no such starting point. But unless you have some directive about what you have to photograph, and, more importantly, what is expected of the material you produce, you cannot do the job satisfactorily.

A sequence is a series of shots that are related and complementary. The standard method is to shoot a principal or master shot; this may be a wide angle of the whole scene. This establishes the action and continuity of the scene. Close-up shots now follow that may be cut into the master shot. How and when this is likely to happen must be known to the photographer so that he or she can produce complementary shots. This basic technique is varied to encompass individual situations.

But everything hangs on the most basic requirement: understanding the story.

## Pictures for purposes

When the idea behind the photography is established, and the story background understood, we are able to offer suggestions about pictures. However, it must be said that photography is a combination of visual skill and craft skills that only comes from experience. Here are a few guidelines.

### Observe

The study of all sorts of pictures is valuable, to see how visual stories are told, and how their drama or humour can be shown. Stills photography is very rewarding when carried out to a theme or plan. Stills are also cheaper to experiment with. Try to visualize movement in sequences of still pictures. A very good way is to produce slide sequences. Add to these sound, in your imagination at first, and you can then get a feel for the relationship between the pictures and the sound.

This sort of exercise has another benefit, for it develops an understanding of sequence. The understanding of cutting points and editing is invaluable when shooting either single camera or as part of a multi-camera crew.

Watch films to get a feel for how drama is built up, and then allowed to subside. Story-telling in pictures uses light and dark as a means to convey mood. As the eye is drawn to a picture highlight, so a story highlight can be emphasized by a visual effect.

The light and shade in the story create rhythm; there is the build-up, and then the release. When faces are partly concealed, the eyes are always looked for. Conceal them to create fear; let them be seen and the audience will relax again. The powerful elements are contrasted with the lighter elements. It is difficult to build up tension without allowing a little relief every so often.

The emotions behind pictures are there for the photographer to bring out. When these little artifices are seen once they will never be forgotten. Use the imagination of the audience to make your pictures do their work.

### Framing

It has been said that to be confined by the rigidity of a frame is wrong. However, we all live in a confined world with rules and limits. There is no reason why we cannot create pictures with frames. Our imagination does so very well. But in the world of standards and systems, such as photography, there is no alternative but to create within the constraints of a frame.

Very serious attempts have been made to expand these boundaries. Wide screen is established in the cinema, and there is now pressure on video to adopt these dimensions. Figure 1.2 shows examples of film and video formats and displays that have emerged over the years. The frame is also the viewer's; it should reveal only what is wanted, no more. There is a skill in concealing what the audience wants to see.

There is a difference between creating images for a small screen and for a large screen. The large screen that subtends a large angle of view carries more satisfactorily a shot containing greater detail than a smaller screen. Note how well the cinema runs whole scenes on just one shot, without failing to hold the audience. Show the same film on the small screen and the effect may be compromised, or at least demands more effort from the audience.

The viewing frame size is very important in the creation of the image. Let us look at movement for a moment. The small screen demands movement and this can be done in two ways: subject movement or camera movement. Either has the effect of changing the pace of the scene.

The rules of framing were laid down in Classical times. They were for the guidance of people creating pictures in those times. It has become very easy today to simply ignore them. But has our human experience moved on so far, outstripping those ancient roots? If the end justifies it, then break the rule. But to ignore old methods and styles is to shut off all that has been learned before. So beware.

There is a wealth of experience to be tapped into. If proof is needed, look at Leonardo da Vinci, Turner, the Impressionists and Constable. Or look at photographers even, such as Cameron, Peach Robinson and Sutcliffe. One could go on. These individuals all used the rules and broke them. These traditional rules are still valid; we can only break them when we know them.

Framing is an art to be learned by those with basic creative gifts. Framing is the understanding of light and shade, movement and position, as well as what should be inside and what should be outside.

The larger the frame, the smaller the subject. The frame imposes itself onto the image by its position and its shape. Unlike pictures hung on a wall, where each has a frame of its own, the moving image has to make do with one frame style for all images. The photographer may create his or her own from features within the scene rather than allow the system to impose its own. Good examples are a window frame, an archway, or overhanging trees.

*Viewpoint: wide angle versus narrow angle*

The frame is the viewer's viewpoint. With it the photographer says how the subject is to be seen. If the camera points up at the subject, the viewer becomes dominated by the subject. If the camera looks down on a subject, the opposite applies. Matching shots make the subject 'look' at the other; the eyelines match when the pictures are cut together. A tall person will look down at a shorter one. The framing should reveal this by placing the camera at the same height as the shorter person. The other shot should show the shorter person looking up.

Wide-angle photography can bring us so close to the subject that we become involved. Because we move closer we are able to see more of it. This does, however, give a distorted view. This is perspective distortion

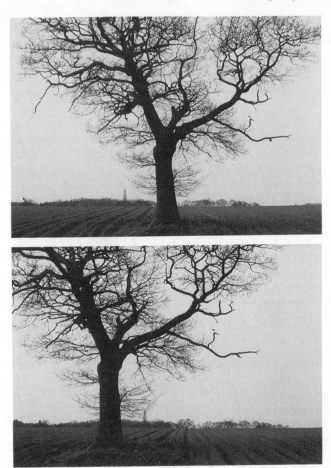

Two identical pictures. The top one has the subject central. This makes
the picture less comfortable to view. The eye cannot move past, for it is
confrontational and static. In the lower picture, the subject is now offset,
allowing the eye to move past by its apparent willingness to make space
at one side. To divide the frame with a central subject is to make two
opposing halves. Placing the subject on the third makes a more
comfortable frame for the subject and space become balanced. This is the
traditional framing, the space on one side being half that on the other.
Grouping and placing other elements in the picture will influence the
final arrangement. Should the subject be a person, placing to one side
allows them to look across the larger part of the frame space. It may be
interpreted as a visual invitation into the frame. This 'looking room' is
often seen in a television interview situation. The subject, by looking
across the frame, suggests something is beyond the frame. In the next
shot we expect to see another returning the look

**Figure 5.1   The law of thirds**

Camera 2

Camera 1

The camera shots show each person 'facing' the other when cut together. This is because both cameras are on the same side of the interview. A line drawn through the subjects divides the scene. If camera 2 tracks across the line, its subject eyeline will swing round to the other direction. Both faces will be presented the same way and not to each other.

**Figure 5.2   The interview**

and may be constructive or not, as the case may be. It can make one subject ugly, and another elegant. Everything depends on the subject and the requirement.

Narrow-angle photography affects perspective by foreshortening. Distance in the picture will become compressed. Distant features become larger, to dominate a subject that is foreground. The brain cannot distinguish between wide and narrow, so the effect is caused by the observer attempting to resolve the scale distortion as presented.

*Tonal values: dark pictures or light*

Visually, darker picture tones convey a mystery because we want to know what they conceal. Dark pictures imply a mood of fear, mystery or danger. Portraying darkness does not necessarily mean using lower light levels. The use of light and shade is the foundation of photography.

To begin understanding this one must first understand the values of light and shade. Light and shade together make a picture dark or light by the way that they play against each other. It is not sufficient to simply make dark to create mood. To the viewer, darkness is only seen in contrast to light. Unremitting darkness only results in the viewer losing interest.

A photographer creates with light. He or she starts with a black frame and adds light to build up the picture. It is what is left unlit that is the trick. The black and white film makers were masters of tonal values, for there was no colour to support the scene. It is a good exercise to experiment with black and white.

In video or film, large screen or small, all these are points that must be practised and applied as the programme demands. Video is a varied and widely used medium with its own virtues and problems. Its small screen in indifferent ambient light makes use of the whole range of light and dark unpredictable in effect. A dark toned picture, however well photographed, may appear in some circumstances as no more than a blank screen.

# CHAPTER 6

# LIGHTING

There can be no picture without light. Nor can there be a picture without shadow. Shadow is created by the photographer.

The subject of lighting is well documented, and this chapter will deal with the basic elements and points to bear in mind where these apply to video. Before this, however, it will be of value to briefly go through the basic principles of lighting.

Photography is a relatively new medium, only some 150 years old. This does not mean there was no understanding of lighting before this, for we have only to visit our local art galleries to realize that the old masters knew very well how to light. Their skill was with brush and paint; their genius was in creating light that stretched beyond natural limits and yet never looked unreal. It is well worthwhile studying these works to see how they used painted light.

The photographer is less fortunate. He has to use real light that accords with all the physical laws of nature. The skill and genius is to bend these as far as possible and to use the imagination of the audience to finish the work.

## Hard and soft

There are two distinct types of light. The first is the light from a point source; the sun is the natural point source. This is hard light, so named because the shadow it casts is clearly defined by its hard edge. The second type is soft light, and the natural source of this is an overcast sky. Here, shadows are very diffuse and diluted by light falling from many directions. Between the two extremes there are many light sources that may be described in varying degrees of hard or soft light.

The important distinction is that hardness or softness of light depends upon the distance between light source and subject. A light source of 1 m² will create a very soft shadow when placed 1 m from the subject. Move the light to 10 m away and the shadows will become more distinct. At 100 m this light source will appear as hard as sunlight. A true point source of light creates a perfectly hard shadow at any distance. But

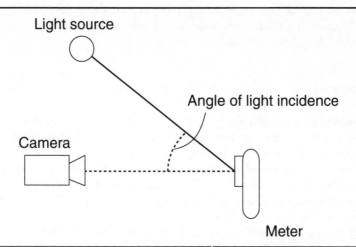

Light source

Angle of light incidence

Camera

Meter

It is convention to measure incident light, or the amount of light falling on the subject. Incident light does not take into account subject reflectivity but when setting lighting situations it is more useful to use incident light measurement. Measuring at the subject is an accumulative measurement of all contributing lighting. The meter sensor should face the camera. The angle of the light will then be taken into account.

Camera auto exposure systems measure scene reflected light. In a moving scene this is a variable and, therefore, auto systems are prone to constant adjustment with scene and camera movement. This is often a distraction and it is normal practice to switch the function off when the scene has movement. It should, however, always be considered a valuable guide. Incident light level is measured in lux, or foot candles. Lux is the metric equivalent of foot candle

1 lux = 10.76 foot candles.

Exposure meters may be calibrated in either unit but as the relationship is approximately a factor of 10, the conversion should not be taxing.

**Figure 6.1  Measuring incident light**

practical lights have practical dimensions and the distance from the subject is a very important consideration when discussing hardness and softness.

Use of shadow in pictorialism has excited photographers for more than a century. Video is just as able to reach these heights of creativity if used correctly. No picture can exist without a tonal range and shadow is part of that. It is quality of shadow that is so important: how hard, how dense

and, of course, where it falls. These are all determined by the quality of light. Is the source small or large, how bright is it and how may we control the density of shade?

## Contrast

The hardness or softness of light is unaffected by its brightness, or by the difference between the illuminated subject and its shadow. This is the next important element in lighting; the contrast between light and dark. Cameras are limited in how much contrast they can accommodate between illuminated and shadow areas of the scene. There are also very considerable differences between cameras. Film has different characteristics to video.

It is unusual to rate a video camera as one would a film stock. (Chapter 7 goes into camera set-up.)

Modern film stocks offer considerable choice to the photographer. Choice of emulsion and processing to give the right speed for shooting in bright or dark conditions may also affect how well contrast is handled. Contrast may be gained at the expense of film speed. Such parameters are well documented by the film manufacturer so that the photographer can predict how the final pictures will look. Tests are often carried out before a shoot to prove that the idea works; after all, film pictures cannot be seen until processed.

The instant pictures from video may seem to offer the ideal answer. But as we have seen in earlier chapters, this relies very much on how we view them at the time. Contrast and tonal values are not always displayed accurately in the field by location monitoring. There is still the need to understand and have confidence in the photographic procedure.

Chapter 2 referred to video limits. There is a video black level below which the system is unable to render pictorial values. White is also clearly defined. At 100 per cent of video the signal reaches peak white, that defined by the broadcast chain as the maximum permissible. If pictures have information above this level the transmission chain removes it. However, the camera CCD light sensors are well able to produce a video signal over a very wide range of light levels. Unless some means is provided to control this it is quite likely that signals exceeding peak white will be achieved.

In television such action is very important as it is quite undesirable to allow signals that exceed the maximum. So peak white clippers are incorporated that remove any excess before the signal leaves the camera. The effect on this upon a useful contrast range is very significant. A scene may have values that naturally exceed this and any removal of these higher tonal values spoils the result. It is a question of (1) exposure, the amount of light allowed to enter the camera, and (2) contrast, the difference between highlight and shadow. These must be controlled by the photographer.

Lighting correctly is the first requirement. The amount of light used and its control on the subject should provide the contrast range acceptable to the medium. These then are the basic natural elements of lighting. Understanding them is fundamental to photography and is where the craft of lighting commences. The methods of contrast and control are looked at later in this chapter.

## Practical considerations

If we take a camera outdoors, the lighting we have is determined by where we are, what time it is and the weather. These are the controlling factors of natural light and together decide how our picture will look. Artificial light can be any combination of hard and soft light, and from any direction. We may place our lamps as we wish to throw light wherever we want. To illuminate an area we do just this. The eye forgives lighting very readily if there is sufficient. But this is not lighting for the camera.

An image has to be created by light in a way that is familiar to the human. This is the fundamental difference between lighting for illumination and lighting for photography. Our human experience is of one point source of light. This dictates a single shadow. We are also able to see into the shadows. Our image must allow this also. These are the two laws that govern our photography. All our use of light must follow these laws, unless by breaking any rule, we are able to move our visualisation to a higher plane and make the imagination work for us. This is creative lighting.

The simple lighting of nature has to be understood fully. Photographing with such simple elements has excited photographers for a long time. Lighting is the essence of all photography but must be utilized in the manner appropriate to each individual field of operation. To create an image of a face using a single hard source, just as the sun does, is straightforward, just as the image obtained will be straightforward. The first natural requirement is a single shadow; one light makes a single shadow. The second, to see into the shadow, may be a little more tricky; it demands an amount of light to fill in the shadow so that the detail hidden there can be seen. This additional fill light must cast no shadow or the first law will be broken, which in such a straightforward picture will not be justified. Only one kind of light fulfils this requirement, soft light, the shadowless light.

Going beyond this basic picture to one that is more exciting, or dramatic, or attractive, requires that light be used more creatively. Turn our subject around to place the hard light behind. Now the face is in darkness and we immediately create a picture that may be considered sinister, or even ridiculous, but is no longer straightforward. Bringing soft light into the face allows it to be seen once more; the hard light effectively rims the outline of the head. This may be dramatic or attractive, depending on the subject and how well it is executed.

Drama and mystery are very closely related in that the effect is created

by the use of shadow. Here, the major part of the picture may be dark to create the desired effect. Such a picture is called low key, whereas a picture that is dominantly bright is said to be high key. These terms are common to all forms of photography but an unfortunate confusion often arises with them. The name given, particularly in movie work, to the principal light of a scene is the keylight. This light is usually a hard source, its dominance being determined by the contrast between highlight and shadow. The keylight does not necessarily determine whether the overall effect on the picture is high key or low key. The distinction between these terms is important to understand.

How the individual images work out depends, of course, on the subject as well as the lighting. Each face takes light differently. The understanding of these finer points of lighting comes only from observation and study, practice and experience.

## Moving pictures and video

Video is distinct in that it is a moving medium, is electronic and, as already stated, makes use of a relatively small display, often under less than ideal conditions. These factors have varying influences on the lighting style for the medium.

Let us consider these individually.

Movie photography is well established and documented as a cinematographic medium. Video gains particular benefit from strong moving images to involve the audience more closely, offsetting to some extent the problems of a small viewing angle. Moves of camera or subject, or both, must be considered carefully to make full use of the effect. The lighting for these moving situations becomes more complex and will need to planned.

It is important to bear in mind that a moving scene invariably means a moving background. Backgrounds are as the word states; a background. Any intrusion of this into the picture may cause it to dominate. The addition of movement may exacerbate or relieve this, depending on many factors. Background design becomes a very important consideration for this reason. In general, the more fussy the background the more difficult it is to make acceptable panning and tracking shots.

The use of the zoom facility is technically a move. Where the zoom rate is fast enough to be observed, in fact to be a visual feature, then one must be careful how this is conducted. A framed shot is correct for only one angle of lens. Change the lens angle and the framing will almost certainly demand changing as well. It is one of the most common and one of the most boring moves of all to simply change lens angle without a complementing camera move as well. It is essential that both framing and zoom angle are considered together.

Any movement has lighting implications. Lighting influences movement greatly. Even still images may be said to have movement that arises from lighting effects. It is quite reasonable to move lights as well as, or

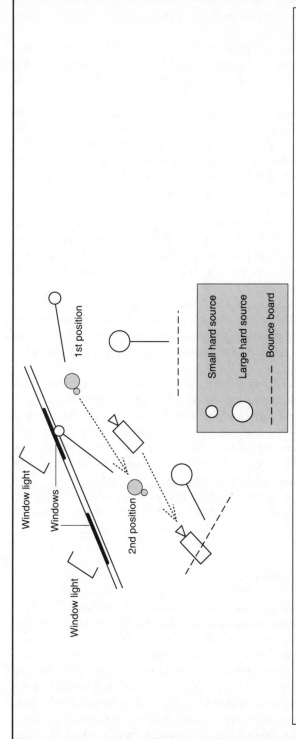

Window light

Windows

Window light

1st position

2nd position

○ Small hard source

⬤ Large hard source

----- Bounce board

This simple walk is lit for daylight. The artist walks past two windows as the camera tracks back. The main light direction is from the windows and this light is soft. The small hard sources are backlights to 'kick' or rim the artist. Fill light is from two bounce boards. The backlights do not cover all of the walk. The first mimics an interior light and is warm coloured. The second mimics the first window; being a hard source, it is barn-doored off the camera lens. The fill light direction also changes along the set. This is a situation with lighting design based on the set. The effect of moving through light may be used anywhere where there is value to be gained by this effect

**Figure 6.2  Lighting a walk**

instead of, the camera. But whatever the choice, it must depend upon its value to the shot and how successfully it can be done. It is better to simplify rather than compromise.

Moves are demanding of lighting effort; factors to consider are the number of lamps, where they are placed and their concealment. Moving pictures can be wonderful if well done, but ruinous if not. Their success comes from experience.

Modern video cameras are not always the easiest of cameras to operate successfully in moves. They are often too light in weight, making it difficult for the move to be conducted smoothly. A heavier camera has resistance to jerking and sudden changes of direction and velocity. A camera of full broadcast specification, fully equipped with lens remote control and on the correct camera mount for the job, is designed for proper camera moves.

It is not necessary to expect every part of a move to be covered by light. There is great visual strength in allowing the shot to pass through areas of darkness. This is not to say that patches of light and shade can be cast anywhere. The eye responds to lighting effects in very specific ways. Highlights will draw the eye and so have to be controlled, for they may dominate the scene. Dark areas and shadow may also be attractive, because an element of drama may be appropriate. However, mystery is not always expected. All photographic situations will demand attention to these aspects of lighting, so that appropriate lighting may be provided for any given scene.

Nor is it necessary to wash every part of the set with light. Light and dark in static elements are just as important. An experienced artist 'feels' light; let them move through the light and use it to best advantage. Such action can only be successful when both artist and camera operator understand each other. It is important for them to work out how the move and the dialogue will run together. A camera move could easily be used here. The camera may track back, pan and zoom all in one co-ordinated move.

The lighting must take all these factors into account and this situation is, therefore, a complex one to make work well. When it does the results can be very satisfying.

## Sharpness of the video image

Resolution, or sharpness, of video is enhanced by artificial electronic sharpening, or detail. This is applied in the camera, appearing as an edge enhancement around objects. Pictorially this feature has become much less obtrusive as sensor resolution has improved. But it has to be considered where backlit subjects are present. A silhouette against a bright window may take on the appearance of a cut-out as the electronics insert a black line around the subject. Strong back lighting will make this more obvious. The effect may be alleviated in three ways: reduce the brightness of the window; light the subject from the rear quarters to reduce the edge

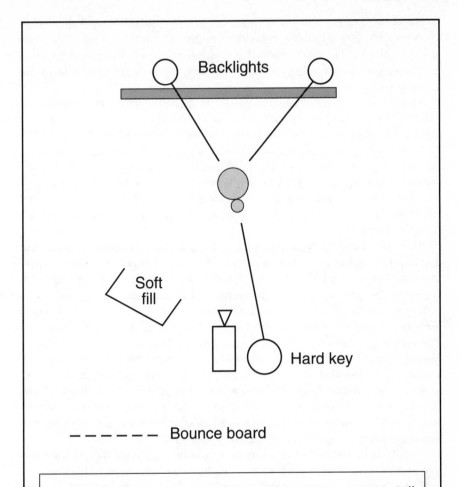

**Figure 6.3  Lighting one person to camera**

The diagram contains the following labels: Backlights, Soft fill, Hard key, Bounce board.

This is the basic television set-up for single person to camera. Still used, it makes use of a hard keylight and rimming backlight for separation for best results from a small, high-contrast display. On a larger screen this could look quite artificial. Two three-quarter backlights work well with long hair but are often replaced by a single light centrally placed. This is a flexible set-up; adaptable for individual sitters with minimum adjustment. The use of spun light diffusion over the keylight is well worth experimenting with. Its use can transform this from a basic set-up to one that is much more interesting to work with

contrast; or use an optical method to reduce the overall picture contrast, such as a low-contrast filter placed in the camera's optical path. Combinations of all three may well be required.

The benefit of back lighting must not be overlooked. Any light that is upstage provides glancing light that picks out texture. This technique adds greatly to the scenic depth by separating subject from background. Video responds particularly well to this style as modelling and sharpness both benefit.

Back lighting presents technical difficulties that must be considered. With light positioned in front of and facing the camera, there is the danger of lens flare.

Control of light falling on the scene is important. There are two reasons for this: to limit unnecessary light spill and to create an effect. Lamps generally have two principal ways of doing this. A focusable spot lamp may be adjusted to increase or reduce the beam width, or this can be done with shutters, or doors that may be drawn across the beam. These are known as barn doors.

Barn doors are in pairs, one pair hinged at the top and bottom of the lamp, and another pair hinged at the sides. These may be drawn in quite close to form a small opening, or vertical or horizontal slots, as required. These useful devices are very common on hard source lighting.

Alternatively the control may be brought closer to the camera by a flag or gobo. A flag is a panel positioned to create a shadow. A gobo is part of the set (or an individual) that casts a shadow. These may be introduced to throw shadow discretely onto the scene, or to stop light spilling onto the camera lens. The size of the light source is relevant to how well unwanted light is controllable. These devices are most effective with a smaller light source; a point source casts a hard shadow. As the source becomes larger, so the shadow is less defined and a different effect is produced. Which is most appropriate depends on the requirements.

Lens flare in a static situation is more easily dealt with. When the camera moves there is greater danger of the lens catching stray light. The control may have to be a combination of adjusting the camera position and its movement, the light position and spread. But a flag attached to the camera shadowing the lens is usually most effective.

As stated above, back lighting enhances modelling contrast. This may be such as to exceed the comfortable video limits. Highlight brightness may increase so much as to become peak white, an effect often seen on fair hair. This is a technical concern; the peak white limits of the video system may be exceeded and removed. It should be remembered how critical back lighting is, as it is undesirable to spoil what could be attractive hair styling because of limiting in the video system. However, small specular highlights are rarely seen to suffer from the effects of limiting.

## How gamma influences lighting

At the other end of the scale, dark shadow demands a correctly set-up monitor to be seen properly. The measure of shadow detail depends on the amount of fill light present. It is also influenced by the system

characteristic of gamma. As was explained in earlier chapters, gamma describes the relationship of light input to the camera to light output from the screen. This should be linear, but there are many instances where this may not be so. Camera gamma is sometimes operationally adjustable and it has considerable effects on those picture levels between 0 per cent and 50 per cent, i.e. black to mid-grey.

The setting of this control will have a dramatic effect on the shadow detail in the picture. In turn this will affect the amount of fill light used, for the two are largely complementary. The setting of gamma may therefore be used as an operational control as part of the photographic demands. But it must be remembered that the viewing monitor or receiver is the other part of the gamma chain, with just as great an influence. We return, once more to the value of properly set up and known picture monitors and viewing conditions.

Camera gamma has a standard value of 0.4, which compensates a monitor gamma of 2.2 (see Chapter 2). Some camera systems may offer other values. If such is the case, it is worth experimenting with a value of 0.45 or 0.5. Higher values than 0.4 move from an overall linear relationship to one that compresses shadow detail towards black, whilst expanding the upper picture tones.

The result is often one that makes lighting control easier. Working with a higher camera gamma reduces sensitivity to shadow fill light. The reduction in sensitivity makes more fill light necessary for the same density of shadow. This makes it less critical to apply, the higher gamma making the camera less sensitive at this level. This is a useful feature when working in low-key drama. Fill light is often difficult to place exactly where required, and making the balance less critical in this way often helps. Higher gamma also creates extended high picture tones. This may benefit those pictures demanding a more dramatic style, but light levels will now be more sensitive at the facial level. Facial features and portraiture are particularly affected by changes to gamma.

Those with a film background may be familiar with adjusting film speed, or ISO rating, and compensating with development to extend shadow detail range at the expense of sensitivity. Such a technique is very similar to the video gamma adjustment described above.

Alteration of gamma may make a noticeable change to colour saturation. Raising gamma will tend to produce more facial colour and less shadow colour. Experimentation is well worthwhile to see if the good points are not spoiled by the bad ones.

## Electronic contrast control

Further to this discussion is another video feature of contrast control. It is called variously knee or DCC (dynamic contrast control), depending on the manufacturer of the camera. This feature operates on the top portion of the video signal, typically where skies and bright windows feature. The

camera is able to reproduce these highlights, only to be subject to clipping back to 100 per cent by the limits of the system. It seems, therefore, a great pity to throw them away.

Instead of allowing the signal from the sensors to just go on rising unchecked in this way, a control above about 85 per cent is introduced. It takes the form of reducing this rate of rise to allow more light input to be accepted. The term given to this is 'knee', a traditional television term derived from the way the waveform is altered. It is a compression of scenic highlights and appears as tonal detail where clipping would have produced a bland white. A further development is to make the effect continuously variable, the degree of compression being controlled by the light entering the camera, the effect only being initiated when required on large and significant areas of highlight.

Film workers will find this a familiar feature. Extending contrast by development is an established technique. But film has a serious restriction with this; once you have started, you can not change the development in the middle of a reel. Video contrast control is often a switchable feature, if not totally automatic.

Because these video contrast variables are quite powerful tools, sometimes too easy to adjust, the use of them can become too casual. Film has much to teach here, with its demands of understanding imposed by the very nature of its mechanism. Video should have the same understanding and care applied if it is to show the same degree of visual excellence.

## Contrast control with filters

A common contrast problem is that between sky and ground. Where this is clear-cut there is an optical solution. A camera filter that has differential transmission from top to bottom is available and is known as the graduated grey filter. This has a neutral density band across one half of the filter. Its value is limited to static shots as camera movement may reveal the presence of the filter.

There is also the low-contrast filter. Here there is optical compression of the image tonal ranges. There is also colour desaturation by the same mechanism. All light striking the filter is subject to mixing with lighter areas, providing additional light to darker ones, and vice versa. This filter can be very effective at reducing contrast but will usually also present an observable effect which may be desirable or not.

The value of the all-adjustable video system comes into its own only if and when it is thoroughly understood. The overriding consideration in this discussion on lighting and contrast control has to be the viewing arrangements. Always ensure the monitoring is not influencing pictures without your knowledge by making use of the methods described elsewhere in this book.

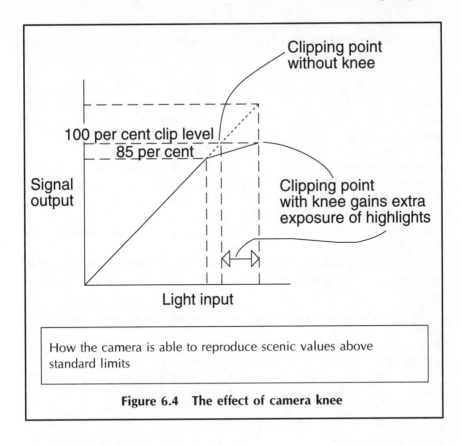

How the camera is able to reproduce scenic values above standard limits

**Figure 6.4  The effect of camera knee**

## Daylight and artificial light

The terms 'daylight' and 'artificial' light describe the light colour. The eye sees light as 'white'. At least the brain always assumes that the subject of its observation is in white light. If it is not , the brain corrects the result back to neutrality. Even in conditions of varying colour the eye compensates very well. This natural process has now become distorted, or sophisticated, depending on how you value this, through exposure to artificial pictures.

Pictures are made using natural daylight or artificial light that may differ in colour. The camera has to be told what that colour is so that it can compensate and reproduce grey and white without colour distortion. This operation can be automatic and continually updating as time goes by, just as with the eye, but it will never be as subtle. The process of white balance is discussed in Chapters 3 and 7.

## Colour temperature

Colour temperature is defined by a law of physics which states that the colour of a black body radiator is dependent upon its temperature. At

zero Kelvin (0°K), or absolute zero, the object does not radiate. If there is no radiation neither heat nor light is emitted. The object is therefore black. Any object when raised in temperature above this point emits radiation.

From this definition, true black is a theoretical concept, at least here on earth. But it illustrates that the term 'black' must be used with care, for it is only a relative value. Colour temperature is often used to describe how warm or how cold light is. Unfortunately the terms colour temperature and warm and cold light are confusing.

As the temperature of an object rises above 0°K, radiation will be given off. At first this will be infrared, which is heat and invisible to the eye. The object is still appears to be black. As the temperature rises further, the infrared is added to by visible light radiation. A dull red glow appears at about 1000°K, and then a brighter red. Orange is followed by yellow and then white heat.

Tungsten is an element that withstands temperatures of over 3000°K in an inert gas and is used to make the filaments of incandescent lamps. A

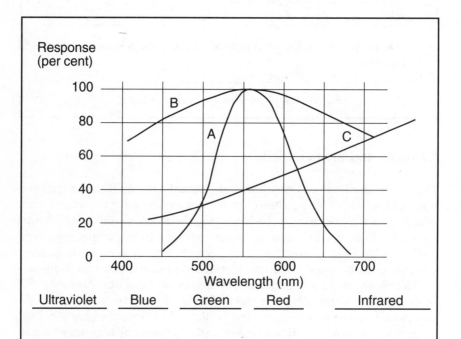

Curve A is the eye's response. Curve B is the sun at 6000°K. Curve C is a tungsten lamp at 3000°K. These are not absolute values but indicate how the colour spectra compare to light wavelength

**Figure 6.5   The eye's colour response and radiation**

tungsten halogen lamp operating at 3200°K has a colour temperature of 3200°K. This is the basis of colour temperature; by referring everything to the physics of radiation, it is possible to give an absolute value to light colour. This operates from red to blue and passes through a value that is white.

We must appreciate here that the value of white is what our eye sees as white. A standard value has been given for this based on pure sunlight. Natural light is daylight, but, as this varies quite considerably, closer definition is required. The value of white in daylight is defined as that of the sun at about 6000°K. This is an ideal sun in a clear sky. Even this definition is not perfect; either side of noon the absorption of blue high frequency radiation by the atmosphere increases, leaving a larger proportion of red and orange to fall on the scene. This explains the red casts and sunsets and a colour temperature that progressively falls the nearer the sun is to the horizon.

On a dull overcast day the light takes on a more blue cast. Blue light penetrates cloud better than red light and so at ground level the excess blue produces a colour temperature higher than open sun. About 7000°K is common, while the light of clear blue sky is about 10 000°K. Actual values will depend on conditions.

The confusion arises when considering the aesthetics of warm light and cold light. Traditionally, warm light has that reddish glow one obtains from a warm fire. This natural feeling of well-being is often conveyed in lighting terms by reddish-orange light, mimicking objects hot enough to glow, such as embers in a fireplace.

At the other end of the scale, the icy feel of winter is conveyed by a weak sun low across a landscape of snow. There is no practical reason for blue light here; the sun's temperature does not change from summer to winter and ice reflects all colours equally. Instinctively, though, blue seems the opposite to red, or orange, and therefore has an association with coldness.

This association of red with warm, thus making blue cold, is in contradiction to the physical laws of colour temperature, which state just the opposite.

On a summer's day, the bright blue sky will have a colour temperature of 10 000°K, a very cold light in colour temperature terms. This is very obvious when shooting in the sun and then turning to shoot in the shade.

Beware, therefore, of the confusion that can arise when talking of high colour temperature and warm lighting.

On the same note, moonlight is often portrayed as blue, in various degrees depending on style and photographic fashion. There is no physical reason for this; light reflected from the moon is similar to sunlight. What gives rise to the effect is the eye's reaction to low light levels, which is to remove colour. It is then an optical illusion, or an assumption, to see the result as more blue. And the film industry has been using blue light consistently for many years to represent the night-time outdoors.

## Light sources

As we have seen, the colour of daylight is not constant. The principal light sources are natural light or daylight, as already described, and artificial light. There are a variety of types of the latter, the principal ones being tungsten, discharge and electric arc.

Tungsten is used in filament lamps and the tungsten light is the traditional domestic artificial light. It uses a heated tungsten wire filament in a gas-filled glass bulb, and has a very predictable colour temperature when operated at its rated voltage. Tungsten lighting is simple, with continuously adjusted light output from zero to maximum, a very valuable feature indeed.

Discharge lights are numerous in type. They operate by causing a gas to glow by electrical excitation. The most common in film and television use is the HMI. The colour temperature of this approximates to that of daylight. This lamp has some four or five times greater light output than a tungsten lamp of the same power rating. Fluorescent lighting also has a higher efficiency with, in many cases, a choice of colour temperature depending on tube specification.

The conventional hard light, luminaire or lamp, is a fresnel spot. This is a focusable lamp of variable beam spread using a parabolic mirror behind the bulb and a fresnel lens in front. The bulb may be a filament or discharge type, the optical principal remaining the same. There are two bulb positions. Position A is for wide beam, position B for narrow. The narrow beam is proportionally higher intensity. There is therefore control over spread and light output. The size of the light spot (that is the source as seen from the object) is smaller at A than at B, causing the degree of hardness to change

**Figure 6.6   The Fresnel spot**

A feature of discharge lighting is that the colour temperature is designed into the device by selection of the discharge gas or gases, and the operating conditions. Each will produce a light of quite specific colour, often described as monochromatic, or one-colour. With the right mix of gas, and correct operating temperature and pressure, specific colours can be produced that combine to make light of predictable colour temperatures. Because the light is synthesized from these component colours, these should match the colour analysis of our system if predictable results are to be guaranteed. This is not always the case. The eye differs from the video camera. Film is analysed differently from video. In practice, the differences are not usually excessive, but there are situations where colour errors may be seen.

Discharge lamps are often of fixed output and, if adjustment is available, this is usually of limited range, say down to 50 per cent output. They also require additional control systems that add considerably to their weight and bulk.

Carbon arc lights are now less common because of the physical size and weight. These lights also require a source of DC (direct current) power. The common power supply today is alternating current (AC), because of its flexibility. Direct current is only available from special mobile generators. Arc lighting is high output and was of particular value in the days of low-speed film emulsions. The source of light is the electric arc between carbon rods. The heat generated creates a plasma, or gas of high enough temperature to radiate light. This ball of white-hot gas is quite small, being only 2–3 cm across, making a very distinctive hard, brilliant light. Colour temperature is very similar to daylight.

## Colour temperature correction

As already stated, clear sunlight is 6000°K and a tungsten filament lamp that is operating at about 3200°K has light of that colour. When using sunlight and tungsten together, the colour difference will show. The success or otherwise of this combination depends on the photographic requirements of the scene. But for most situations it would be necessary to correct one light source to match the other. Which one is adjusted will depend on circumstances. The colour balance of the camera may be set to work in either situation. Whichever source is adjusted, it will be necessary to colour correct that light until a colour temperature match of the two sources is achieved.

A feature of tungsten light is controllability of light output. It is possible to operate such a lamp at reduced light output, this dimmable feature being made use of in studio systems to balance light levels. But as the lamp dims, so its filament temperature falls making the light more orange in colour as well as reducing light output.

This is also a quite valid way to alter the colour temperature over a small but significant range along the red–blue axis. This is an invaluable

feature; for instance, it might be quite pleasant to use a low-run backlight as a hair light. This may bring out a natural hair colour quite well. Reducing the light level on the face may bring out facial colour better. Adjustment of relative lamp levels can provide a very useful technique to make the most of a simple lighting situation. There is often the need to make these cope with a variety of different sitters and their individual photographic requirements.

To make use of colour temperature in a tungsten studio, balance the camera (or cameras) using a low-run lamp. Now a lamp at full output will be seen on camera as more blue: there will be a range of colour control from warm, with lighting below the reference lamp, to cold with fully run lighting. Chapter 7 explains camera colour balance.

Differences in the colour temperature between various light sources makes correction necessary under many circumstances. Correction of colour temperature is carried out by filtering the light. There are a number of correction filters available for shifting colour temperature up or down. Such filters are similar to those used to alter the colour of light entering the camera.

The most common unit of colour temperature in television is the kelvin, derived as we have already seen above. Film uses a system based on Mired values.

$$\text{Mireds} = \frac{1\ 000\ 000}{°K} \qquad \text{Therefore, Mireds} \times °K = 1\ 000\ 000$$

**Table 6.1**    Colour temperature and Mired values

| °K | 2000 | 3000 | 4000 | 5000 | 6000 | 7000 | 8000 | 9000 | 10 000 |
|---|---|---|---|---|---|---|---|---|---|
| Mired | 500 | 333 | 250 | 200 | 167 | 143 | 125 | 111 | 100 |

From this can be derived the Mired shift value for any colour temperature change. For instance, altering daylight to tungsten, 6000°K to 3000°K, is a Mired shift of −166: Filters can be quoted according to their Mired shift values.

There are slight differences between film and video in what is considered standard daylight. Film uses 5500°K, while video uses 6000°K. This is a small difference that may prove an irritation. It is worth checking the value of daylight for the particular camera in use. In the same way, tungsten light also has slight variations. Domestic light is 2900°K. Photofloods and halogen lighting are 3200°K.

There is only one way to settle what colour temperature a particular light source is, and that is to measure it. Colour temperature meters are widely available and easy to use. They usually indicate in kelvins, but may also give the colour co-ordinates. They normally read light level as well.

Colour correction filters are available for both lighting and cameras. Correcting a lamp is an individual adjustment, whereas a camera filter corrects the whole scene. Correcting the camera by filtration is more

applicable to film. It is not possible to alter a roll of film once it is in the camera. Video colour correction is electronic. This is very easily altered shot by shot, and so there is little need to place filters over the video camera lens.

It is, however, quite legitimate to place a lighting filter over a camera lens in one particular situation. This is where the camera is forced to produce a colour cast. Colour balancing the camera through a gel of the opposite colour will cause the camera to compensate and produce a desired cast.

## Hot lamps versus modern cameras

The characteristics of lighting and camera filters are almost identical, but there are subtle and very important differences that must be understood. Firstly, there is a safety consideration. Lamps produce considerable heat in their output. All filtering systems designed for this purpose are heat resistant. Filters for camera use must never be placed on or near a lamp, as this will result in a fire hazard. Lighting filters are not required to have good optical characteristics, so placing these over a lens is not advised.

As video cameras and, for that matter, film stocks have improved in sensitivity, so lighting levels have fallen. This is a valuable benefit where cost is concerned. Less light means not only smaller lamps, but also less heat output (which is a waste by-product). This is a most important consideration both for small enclosed locations and for air-conditioning in studios. Operating video cameras with increased sensitivity switched in, analogous to uprating film stock, allows light levels to be reduced even further.

Such decisions may not always rest with the photographer. It may be company policy to save money in air-conditioning, or there may not be the lighting power available for the job in hand. Either way a compromise has to be struck. Operating video cameras uprated, usually referred to as having gain switched in, has a similar effect to uprated film: increase in grain, or, in video terms, noise. Chapter 1 sets out the background to video noise. Cameras perform better at their basic rating – unless, in photographic terms, the result justifies changing this.

## Colour effects

Filtering to make colour effects is a very common practice. There are so many subtleties and shades as to make almost any conceivable coloured effect possible. There are two considerations. First, the eye does not see the same colours as the camera. Second, placing filters in the light path reduces the light output of the lamp.

The colour perception problem exists throughout all photography. Video light sensors can, by themselves, be considered fairly polychromatic, i.e. having a good response to the visible spectrum. But in the process of producing colour pictures, analysis of this spectrum is made in

terms of red, green and blue. It is in this analysis where differences arise. This influences our coloured effects considerably. We can only judge these through the camera, the eye will deceive. Errors show particularly in red/blue or magenta and in the green/blue or cyan, the video complementary colours. Additional complications arise in viewing the picture where the picture is reconstructed from the three colours

## Diffusing the light

A very indeterminate description of light is often heard in lighting circles. This is 'quality of light'. This means something different to each individual, often being used in the absence of real quantifiable values. There are so many personal styles and techniques of creating pictures with light that it is not surprising that such a valueless term has come into common usage. Quality of light only means how well, or badly, a particular style or character of light may be translated into a picture. We have set down standards of hardness or softness, colour, contrast and amount. Little else remains to be defined. It is the innumerable combinations of these that create the quality.

One such combination is that of diffusion, produced by placing various kinds of material in front of the light. True diffusion is to convert a hard source of light into a soft source. A lamp pointing at a panel of diffusion material is an example; the light source changes from a point source to become as large as the panel. However, by altering the type of material such that some of the light is transmitted without hindrance, i.e. it remains hard, whilst the rest is diffused, a combination of hard and soft light from the same direction is achieved. It is the property of coming from the same direction that is important.

Such material may be called spun or frost, names that describe either its construction or appearance. There is also another value to be made use off. Placing material over part of the lamp allows differential light output; one half may be brighter than the other. This is very useful in controlling light levels foreground to background. But it is the ability to soften shadows particularly across the face that gives this material real potential in creating that special quality of light.

## Observe and study

In this chapter we have only glanced at this very heart of photography. Lighting is the skill-intensive craft used by a creative imagination. Only if this craft is learned will this imagination be realized. Video is no less demanding in this respect than any other form of photography. But it is unwise to restrict one's studies solely to one medium, as photography is so large, with so many disciplines, styles and practitioners. Study and practise whenever and wherever you can to establish your own techniques to suit your own abilities and inclinations.

# CHAPTER 7

# PREPARING THE KIT

In Chapter 3 both camera and monitor were discussed as one interactive unit. We now move into practical situations and prepare the equipment before shooting.

There are two distinct styles of operation: location and studio. The two are related in that many of the procedures are similar. The principal difference is that location work is mobile and so it is technically simpler. Studio work involves a more complex permanent establishment. Operationally, the former is usually single-camera whereas a studio is multi-camera.

The operational distinctions may very often become less clear-cut; more than one camera may be used on location, or a studio production may require a single camera. We will start with the preparation of a single camera before a location shoot commences. The studio system will then be treated as a development of single-camera working.

Always use the equipment's manual where available. These give an invaluable insight into the designer's thinking. They are often a boring read, which is a pity, but do contain useful information about what controls are available and where.

## Single-camera operation: film-style video operation

The most important thing to do before the shooting day commences is to check the system. Principally, this involves checking the camera's principal parameters and checking that the signal reaches its destination, whether this is tape or transmission line.

In Chapter 3 the concept of camera and monitor as one unit was discussed at length. The underlying principle of always considering what the viewer sees is paramount and this can only be guaranteed by knowing what the camera will produce.

The full procedure is set out but, obviously, this may be adjusted as experience is gained.

We assume the camera to be in sound working order but, if it gives confidence, use a waveform monitor to prove that the signal output is correct. Chapter 2 describes the waveform in some detail and this is able to provide much more information than a non-engineering person may feel

comfortable with. But if a waveform monitor is available the following checks may be made:

1. Select colour bars and check that the signal is as described in Chapter 2.
2. If the destination is tape, record the colour bars and replay. View the replay on the waveform monitor. The signal will differ from the original if the recorder is analogue; some distortion will be evident. An engineer will interpret this if required. A digital recording is unlikely to show any difference from the original.
3. A useful and quick check is to see if the green bar (fourth from the left, including white) touches black level at the bottom part of its envelope. This is an indication of correct colour saturation in the camera's encoder (the device that sends the signal down the cable as PAL or NTSC). This is particularly valuable, as colour bars from the camera will be measured at the signal destination. If this check shows an error (say, in excess of 10 per cent) the camera should be checked out and set up by a engineer.

In picture terms, there is little more that the waveform monitor is able to do. But if it is left in place (assuming it is available), it will be of assistance in understanding more about the system.

Setting up camera and monitor requires a methodical approach, as both have very similar effects on the picture. For instance, overexposing the camera and then turning down the contrast of the monitor will have opposite effects and tend to cancel each other, so making the picture appear correct. Such a combination with two variables is unreliable and unless some means is provided to guarantee one of them, disastrous results may result.

The most straightforward method for the photographer is to use Vical. This will enable very quick assessment of monitor set-up and will immediately point to camera or monitor errors.

*The method*

Set up the camera and monitor in a convenient place, making sufficient light available to expose the camera.

Instal Vical in the video feed between camera and monitor.

Keep the monitor screen away from the light, shielding it if necessary. In most cases a small location/battery-type monitor will be adequate. If a higher grade monitor is used, bear in mind the requirements of lower ambient light. Be aware that the smaller monitors and receivers may have less good picture control. LCD monitors may show a restricted viewing angle. They may also exhibit other differences that will need checking out, e.g. tonal range and gamma. If in doubt, consult the manufacturer's handbook to make sure you use the monitor in the correct manner.

Whichever is checked first, camera or monitor, will become a personal choice as more experience is gained. In any case, both will be offset at times during the procedure to make specific observations. The principle

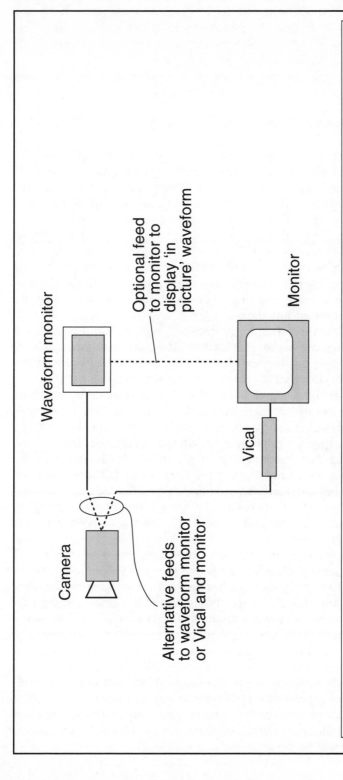

**Figure 7.1  Camera, monitor, waveform monitor and Vical**

Set up in subdued light. Provide sufficient light to properly expose the camera. Try to have sufficient room to move around in the dark without knocking the tripod or lamp

that the two are dealt with as part of a whole makes the distinction between them less obvious. As the various functions are undertaken and understanding about what is actually happening develops, the user will soon work out preferred methods and practices.

At this early stage it is logical to check that our monitor is functioning reasonably before the camera picture is looked at.

### Checking the monitor

Cap the camera lens, or stop it right down. Now the only signal to leave the camera will be black, i.e. camera or picture black. And, of course, all the synchronizing pulses of the signal will be present as well; although there will be no displayed picture, the video signal will still be complete. There should, therefore, be no light leaving the monitor screen.

To achieve the latter there is a real temptation to adjust the picture brightness until the screen is, in fact, black. But let us do a small test here.

Raise the monitor brightness until the screen shows some brightening and we see it become grey. Now reduce the brightness until the screen is black. Continue moving the brightness control and observe that the screen does not become any darker.

Which is the correct setting for brightness? Is it just as it extinguishes, or a little brighter, or maybe a bit darker? The exact position is open to dispute when using this method. In any case, the camera black may not be correct, for it is this that the monitor is actually showing us.

Let us break into this signal between camera and monitor. Switch on Vical and select 'set up'. A three-bar display will appear on the monitor. The black bar at the left-hand edge of the screen is at video black, i.e. system black. Raise monitor brightness and, in most cases, the black bar will be identifiable against camera black, or picture black. The camera's picture black should show brighter than the black bar and, if so, the monitor brightness may be confidently adjusted until this difference is just observable. The brightness is now set correctly. If your monitor fails to reveal any difference between camera and video black, then bear with it for the moment.

Adjust the 'level' control on Vical to maximum (the level display will read about 110 per cent). The white bar and grey bar will appear to be the same – almost. In fact, the grey bar has been adjusted to exceed the white by 10 per cent and this difference should show. If it does not, then the monitor is unable to deliver this amount of light output and its contrast should be reduced until you are able to distinguish the difference. If you fail to see this difference under reasonable viewing conditions, the monitor is faulty.

These two tests will show if the monitor is able to function reasonably well. The two principal controls of brightness and contrast are now set so that the camera's picture can be viewed. One very valuable point will emerge from all this; how critical the setting of brightness is. A pointer to how important will be the setting of camera black.

The viewfinder, of course, must not be forgotten for, in many cases, this will be the only form of picture display. The same comments apply as to monitors but the use of Vical as a set up system is not available for the viewfinder. One has to rely on careful observation. Compare the viewfinder to a monitor, correctly set up by using Vical, as detailed above. The following may be used as a guide but it is experience above everything else that is the key here.

1. Cap the camera lens.
2. Set V/F Brightness to make the display just at the point of being seen.
3. Open the lens and point at a black card. Zoom in and out. Does the level of the black card in the V/F alter? This indicates how accurate the V/F displays a scene black.
4. Set Brightness to the most ideal position when 3. above has been checked.
5. Set Contrast for the most ideal.

This, unfortunately, is hit and miss when compared to monitor set up. But always refer to a monitor placed alongside. Practice is the only way. Get to know how your viewfinder responds to various types of scene and develop your own method.

It will be found useful to add a piece of black card to the Kodak cards. Caption or mounting card, is ideal, preferably with a matte finish. The three principle scene tones will now be available to you.

Although using a monitor on location may not be practical, where there is the opportunity to view the day's work afterwards use it. Check that your exposure and colour balance are as you expect. Vical is still as valid after shooting as it is before if the recorder playback is acceptable for viewing reliably. Use it to check the results, at least it may stop a problem with today's shoot cropping up tomorrow.

*Camera black or pedestal*

1. Cap the camera lens, or adjust the iris right down to closed.
2. Switch Vical to 'measure'. Only the greybar will remain, move this to screen centre. Adjust the grey bar level until it matches the camera black. Read off the level of the grey bar on Vical. This should normally lie between 2 per cent and 4 per cent.
3. If this is not so, set Vical to, say, 3 per cent and adjust the camera black level, or pedestal control until camera black matches the grey bar. To observe this accurately it will be necessary to raise monitor brightness, but this is easily reset afterwards as described above.

What is seen here is the difference between video black and camera black. The term 'pedestal' comes from the fact that picture black is raised above video black. This is a critical setting. If it is too low, there is a serious risk of removing the darker picture tones altogether. If it is too high, the picture blacks will become grey and there will be a reduction in the useful contrast range available from the camera. The actual value is what the

photographer chooses. Experience will, in the end, determine what that should be.

The setting of pedestal can be carried out by using a waveform monitor, but it will not be easy to estimate such close values as 3 and 4 per cent. It will, however, show whether the setting is above the all important 0 per cent level of video black, below which the darkest picture tones will appear as black. This is adequate for most purposes but will be difficult to repeat using a waveform monitor.

For those using waveform monitoring, Table 7.1 gives percentage to voltage conversions. Note there are two ways in which voltages may be quoted: (1) from the bottom of syncs; and (2) from video black level. Percentage measurements used in Table 7.1 are based on video black at 0 per cent.

**Table 7.1**   Percentage to voltage conversion

| *Percentage* | 0 | 2 | 5 | 10 | 20 | 50 | 70 | 85 | 100 |
|---|---|---|---|---|---|---|---|---|---|
| *Volts ref.* | | | | | | | | | |
| *video black* | 0 | 0.014 | 0.035 | 0.07 | 0.14 | 0.35 | 0.49 | 0.595 | 0.7 |
| *Volts ref. syncs* | 0.3 | 0.314 | 0.335 | 0.37 | 0.44 | 0.65 | 0.79 | 0.895 | 1.0 |

*Looking at the camera*

A standard Kodak Grey Card is necessary for this. Alternatively, one of the camera line-up charts may be used and, if one of these is available, it is well worth using. Kodak supply their cards in pairs; they are identical, with one side grey and the other side white. The grey side has 18 per cent reflectivity; this means of all the light falling on it, 18 per cent will be reflected, and all colours will be reflected equally, producing true grey. The white side is not guaranteed to have the same accuracy, presumably it is more likely to alter with age, but its reflectance will be about 90 per cent. Display the two cards side by side, one grey the other white, light evenly and frame up.

If a line-up chart is used, all the tones will be available from black to white. But for this discussion we will use the Kodak Grey Cards.

The picture may show the camera over- or underexposed and adjustment of the iris will set exposure to some intermediate value. What is the correct exposure? Both white and grey cards must lie within the system limits. If the value is too high, the white card will be overexposed and subject to limiting. Carry out the following steps:

1. Set Vical to 'measure' and adjust the grey bar level to 50 per cent.
2. Adjust camera iris to bring the grey card to match the Vical grey bar.
3. Now adjust the grey bar level to match the white card. The Vical reading should be about 90 to 100 per cent.

If the above test gives the expected results, then we have checked out the camera for pedestal (when the lens was capped), and for how accurately

the levels of grey and white match what is expected. This is the transfer characteristic, or how well it follows the correct gamma curve.

These results may well vary slightly from camera to camera, but will be an indication of correct internal line-up. Some variation is to be expected. The white card may approach 100 per cent when the grey card measures 50 per cent. Or it may be nearer to 80 per cent (remember, these are signal measurements). Readings outside these are an indication that the camera's internal gamma set-up is incorrect. While this may not inhibit the camera's use, its tonal values will not be standard and this may show when it is compared to other cameras and the rest of the video system.

A waveform monitor will show the difference between the grey and white cards very easily. But here its display may not be so easy to interpret. Uneven lighting of the cards will appear as a slope or thickening of the display and it may prove difficult to work out which part of the card we are measuring. Vical's spot metering ability avoids this problem.

It is now possible to view on a monitor in which we have confidence, a picture that is seen to conform or not to the standard. What else can we check? Colour is next.

*White balance*

The camera will probably have in its memory a value for white. As previously discussed, white is an absolute, the absence of colour. The camera interprets this as it has been designed to do and the result may be at variance from the absolute.

The degree of error may be small but the eye is extremely good at detecting such errors when set side by side. It is quite likely that the camera reproduces a Kodak grey (or white) imperfectly. Using our single camera this may well pass unnoticed. If the camera is to be used with others, either at the same time or as part of an assembled programme, these errors will be seen.

Within the signal such errors are not easy to measure and it is only by comparing the signal with another that an estimate is possible. The signal inserted into the camera's output by Vical has no colour and is therefore perfect video grey. When the reproduced grey card is compared to this, any camera grey error will show on the monitor.

1. Set camera exposure to place the grey card at a level of 70 per cent or 80 per cent.
2. Operate the camera white balance. Look for the viewfinder indication saying that this has been successful.
3. Observe the monitor. Any deviation from the colour of the grey bar is a camera white balance error.

There are some points to bear in mind here. The colour of the light illuminating the card is important. A new tungsten lamp at maximum level, i.e. at its full rated supply voltage, is very close to 3200°K. The camera may have a pre-set white balance for this and this may be selected and

checked. This is equivalent to tungsten balanced film stock. If the light is daylight there will be less predictability. Regardless of this, however, the test proves how accurately the camera produces grey output, not what is necessarily a grey input. So it is important to remember when white balancing to use a light representative of the scene illumination.

The grey card is also specified for the test. The white side of the card is not guaranteed in the same way. Also, other easily obtained materials, such as a handkerchief, or the assistant's white shirt, are unreliable because they may not be as white as one may like to think.

Articles of clothing are also subjected to washing in whiter-than-white agents. The effect is to make them reflective to ultraviolet light. The brain interprets this as bright white, but the camera is less easily fooled, and sees this as blue–white.

## Colouring with white balance

There is another side of the coin; white balance is a creative tool. If the camera makes grey from whatever is put into it as a white balance source (within the limits of its design), it is quite legitimate to make it produce a variation away from true grey. We are able to make the camera have a colour cast of our choice.

For instance, we can operate white balance with a low-run tungsten lamp, i.e. the lamp produces light with increased red–orange. The camera responds to this by reducing the red–orange in its output to produce grey. Now, when operated in normal tungsten light the camera will have a colder, bluish colour cast. In fact, the colour rendition will be towards blue–cyan, which is the opposite, or complement, of the original low-run lamp.

The reverse also applies. Place a gel over the lamp. One of the Wratten 80 series, or a tungsten to daylight correction, will make the lamp more blue. White balancing with this offsets the camera to reproduce with a warm colour cast. Experimentation is well worth the effort to find for oneself how valuable a tool this is.

By checking what inherent white balance error the camera has, it is possible to find a filter combination by experiment, to correct this. Likewise, it is useful to know what filters give desirable colour shifts for entirely creative purposes.

All this is possible to assess using a picture monitor, regardless of whether that monitor is imperfect in its own colour rendition. The absolute grey of Vical is still valid even when used with a monitor of unknown colour balance, for what the monitor does to the grey bar of Vical it also does to the camera's picture. The comparison is still valid.

While we talk at length about white balance, this quite often ignores the colour balance of the remaining tonal values. The camera may well white balance perfectly, but that does not mean that darker, or lighter, grey values will also be correctly reproduced. Check this out:

1. White balance the camera as before.
2. Adjust the camera iris to bring the grey card right down to 10 per cent.
3. Adjust the grey bar of Vical to match and compare to see if the match is still good. Switch off Vical 'Chroma' to make the match, and then restore. It may be necessary to increase the monitor brightness just a little and control ambient light from the screen.

On the waveform monitor, colour errors show as a trace thickening. One can use this as a guide to the amount of error. It will not reveal the colour concerned.

This test can be conducted over the whole tonal range. Colour errors at black are very common, and are particularly noticeable if the camera is operated in a higher gain mode, i.e. increased sensitivity. Although these may not be considered important, black, after all, is black. The eye is very aware of 'colour in black' and its effect in shadow areas. A checkout using Vical will quickly reveal such camera grey-scale errors.

We have now started to consider colour and there are a couple of monitor checks that can be carried out. Colour bars displayed on a monitor are not a very useful picture test, for they were developed to provide a comprehensive test signal from source to destination.

If the monitor is provided with the option of selecting either of the three colours in turn, then it is useful to see the way the signal is built up from the component colours. On location, monitors are invariably used with composite video, i.e. a single feed of coded PAL or NTSC video. If possible, display the blue signal only. A set of blue bars will result. The left-hand one will be the blue component of white. The next bar is the yellow bar; there is no blue here. Cyan is blue and green together, so blue will remain on. And so on all the way to the final colour; the blue bar itself.

Because these bars also contain a luminance component, the white bar, which has the highest luminance, is the brightest. The blue bar will be the darkest. The difference is a measure of the signal's colour saturation and may be measured to ascertain this value. Colour bars are generally accepted as an accurate and standard test signal, and if we assume that they are correct they may be used to set up the monitor saturation.

This is an important parameter. Errors in its set-up will be misleading when assessing colour levels, particularly if the monitor is to be used by make-up artists.

1. With colour bars displayed, select 'blue only' on the monitor. Note that the Vical bars are similarly displayed, with the blue component only showing.
2. Measure the white bar at the left-hand edge of picture. It should be 100 per cent.
3. Measure the blue bar, which is the one at the right-hand side. This should read 75 per cent. Adjust monitor saturation, or 'colour', as it may be called, until the blue bar is at 75 per cent.

Matching the bar levels by eye when only blue is displayed may take a little practice but there is no other way to set up monitor saturation

accurately. Obviously this relies on colour bars being correct, but this is where our checks and those of an engineer differ. It is assumed the camera has its engineering functions set up properly. We are dealing with operational controls.

During this check-out procedure, we must make basic assumptions about the validity of the camera's fundamental set-up. If, during this, any doubt arises, consult an engineer.

*Camera sensitivity*

Many film workers try to evaluate video camera sensitivity in the same way as for film. This is possible to do, but the benefit is doubtful. Film and video characteristics differ and the comparison is therefore unreliable. In any case, for those using an exposure meter, the requirement is to ascertain lighting levels. It is unlikely that there would be any advantage from deriving a video ISO or DIN rating for the camera. The sensitivity of a camera is measured by comparing light in to signal out.

Incident light of 2000 lux illuminating a surface of 89.9 per cent, produces a specific signal level. Adjust the pedestal to 3.5 per cent and expose to place the white at 100 per cent. The indicator of sensitivity is the f-stop, how open the lens must be to achieve the required signal output for that amount of light input. So a typical camera may read f8.0 at 2000 lux off 89.9 per cent. This is one stop more sensitive than one of f5.6 at 2000 lux off 89.9 per cent.

The reflectance value of 89.9 per cent is rather academic. The Kodak white card has a reflectance of approximately 90 per cent and is close enough to get a good estimate. If the same card is always used, it is possible to get very close comparative figures between different cameras.

The video camera is adjustable in sensitivity, and usually three gain steps are provided, calibrated in decibels (dB). This is an uprating facility, available at the flick of a switch. Unlike with film this very convenient arrangement is not limited to a whole roll; it can be used shot by shot as required. It must be remembered, of course, that just as with film, this facility will alter the picture reproduction. Video noise or grain can be adversely affected by uprating, or using higher gain settings.

Exposure of the camera is a user variable. As with film, it is for the photographer to decide what exposure to give the camera. There are limits, similar to those experienced in film.

**Table 7.2   Gain is specified in decibels**

| Decibels | − 6 | 0 | 6 | 9 | 12 | 18 |
|---|---|---|---|---|---|---|
| Gain | 0× | 1× | 2× | 3× | 4× | 8× |
| Sensitivity (stops) | −1 | 0 | +1 | +10 | +2 | +3 |

The camera shutter is its exposure time. The original tube cameras exposed at 1/25 seconds per frame. Modern CCD cameras have variable

shutters, often with a longest exposure of 1/50 seconds per frame. The exposures at other shutter timings are shown in Table 7.3.

**Table 7.3   Shutters**

| Shutter exposure (seconds) | 1/50 | 1/125 | 1/250 | 1/500 | 1/1000 |
|---|---|---|---|---|---|
| Relative exposure (stops) | 0 | −1 | −2 | −3 | −4 |

A 1/60 s/frame shutter is so similar to a 1/50 s/frame shutter as to make little practical difference to exposure.

**Table 7.4   Exposure and gamma**

| Light input | Signal output | |
|---|---|---|
| 100 per cent | Peak white | 100 per cent |
| | White card 90 per cent reflectance | 100 per cent |
| −1 stop | 50 per cent | 75 per cent |
| −2 stops | 25 per cent | 66 per cent |
| | Grey card – 18 per cent reflectance | 50 per cent |
| −3 stops | 12.5 per cent | 40 per cent |
| −4 stops | 6.25 per cent | 25 per cent |
| −5 stops | 3.125 per cent | |
| | Pedestal, or camera black | 3.125 per cent |

From Table 7.4 it can be seen that the contrast range of the camera is five f-stops. Note also the way the signal output expands up 50 per cent and compresses from there up to 100 per cent. This is due to the gamma correction of the camera.

## Contrast ratios

Table 7.4 shows there are 5 stops from peak white at 100% to pedestal at 3.125%. The contrast range is therefore, 5 stops which is equivalent to a contrast ratio of 32 : 1. Film stocks can exceed this considerably, 10 stops is typical, depending on type of stock and the processing. Compare these figures to a digital camera with 8 bit processing giving 256 discrete levels of signal output. This corresponds to 8 stops, or a contrast ratio of 256 : 1.

Figure 6.4 shows how 'bending' the transfer characteristic in the camera by using a knee extends the available contrast range. Resulting in compression of the upper scene tones.

In practice, how much contrast is actually available to the viewer still depends on overall system limits. Where the darkest tones become obscured by noise (or grain) and the ambient light falling on the picture display, and the maximum light the display is able to produce.

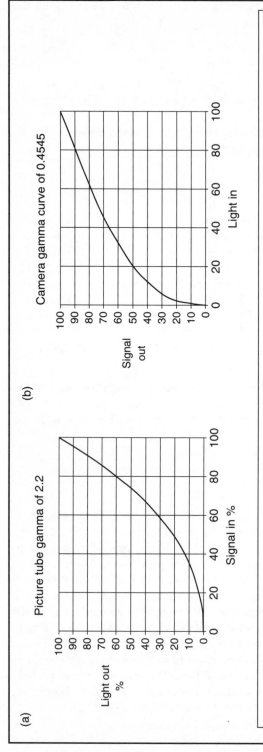

(a)

Picture tube gamma of 2.2

Light out %

Signal in %

(b)

Camera gamma curve of 0.4545

Signal out

Light in

The relationship between an input and output is known as gamma. If this is a linear relationship (output proportional to input), gamma has a value of 1. The standard gamma characteristic of the CRT is 2.2. (This value was determined a long time ago. Recent information, supplied by Philips Components Ltd, show that this is unchanged. This is an indication of the importance attached to compatibility.) To correct this, the camera must have a gamma of 0.4545. Therefore, the idealized overall value for light input to the camera and light output from the screen, will be unity. The system is linear. These idealized values are not achievable in practice. The camera gamma is normalized to 0.4 with a restricted initial rise between 0 per cent and 20 per cent of signal out

**Figure 7.2   The gamma transfer characteristic**

These values may be checked:

1. Use either the grey or white side of the card. Measuring the signal output, expose to make 100 per cent.
2. With an exposure meter reduce the light by one f-stop at a time and measure the signal all the way down to black.

The results should be similar to the above. Variations are likely, but it is a useful exercise for those wishing to apply film practice to video. How close your actual figures will be depends on the camera and how well you measure. Errors will tend to accumulate near black; 1 per cent at black is a much more significant picture element than 1 per cent at white.

Such figures are a guide to exposure. From here it is a question of practice and experiment and what you do will depend on what you require from the pictures.

The value of gamma used by the camera will affect its sensitivity quite markedly. It is possible to alter the sensitivity at mid-grey without changing the signal level for white, analogous to altering the film development curve. Therefore, facial tones at or near mid-grey are affected considerably by changes to the value of gamma.

There is also the choice of auto-exposure, but it is an imperfect system. There is value, however, in letting the auto system find a nominal setting, and then working with it switched out to avoid exposure fluctuation with scene action. It will require proving. For instance, frame the grey card and select the auto iris. This should bring the output to about 50 per cent. This is an internally adjustable function that is an engineering set-up.

### Knees: the additional headroom of highlight compression

Many cameras provide an automatic compression above 85 per cent or so. This part of the signal is usually occupied by skies and windows and it is obviously advantageous to retain these. A conventional broadcast specification camera will not exceed 100 per cent. Its internal signal processing will remove anything above this value to comply with broadcasting standards. This is the peak white clipper. In fact there are three, one for each colour, so that everything above 100 per cent will be clipped to white.

As the sensors are able to exceed the five stops, or the 32:1 contrast ratio, camera designers set about emulating film with its more accommodating upper limit of exposure. This can provide an additional 1½ stops to allow for these highlights and is usually an option available with a switch, to be used as required. This is a non-auto system where the knee acts all the time, causing needless compression when it is not really justified.

More sophisticated control may be automated, letting the scene determine whether or not the effect will be utilized. A method known by such terms as automatic highlight control or dynamic contrast control. The reason for an automatic system is to distinguish between highlights that

will be spoiled if subject to clipping. Larger areas with tonal detail such as sky, initiate the automatic control, pulling them back so that they do not exceed 100 per cent. Small speculars do not call for this and can be clipped at 100 per cent.

Both arrangements are well worth evaluating beforehand so that they may be used appropriately.

In our set-up with the camera pointing at a white card, one can investigate whether a knee is operating or not. If, when steadily increasing exposure, the signal seems to reach a sort of plateau at around 85 per cent then this is probably the point at which the effect commences, allowing the extra exposure range. Alternatively, the point may not be a rigid 85 per cent, but may alter depending on the amount of light over 100 per cent.

Whichever arrangement is used, it is worth understanding in practical terms, so test the system by varying the amount of overexposure. These systems can be quite subtle, but sometimes less so; a bit of investigation is very worthwhile.

### Zebra: the camera's exposure guide

Zebra is the viewfinder indication of signal level. It is therefore an exposure guide. The level at which zebra operates is important. If it is set too low, many higher scene tones will be obscured. In the viewfinder the pattern will prove a distraction, making it useless for its primary purpose of framing the shot. It must also be set high enough to be valuable as an exposure guide. For instance, if it indicated at 75 per cent, then much facial detail will not be seen, particularly on the lit side of the face. Indication of the exposure of the light side is no less important than for the dark side.

Zebra should be set high enough not to obscure faces, and the ideal value is 90 per cent. Many manufacturers set them too low, but they are adjustable. This is how to do it:

1. Expose a card until zebra is seen to appear in the viewfinder.
2. On the monitor measure the level of the card. It should be at 90 per cent. If not, adjust the exposure to 90 per cent, measuring with Vical.
3. Now adjust the zebra control to trigger at this level (refer to the camera manual to find it).
4. Check by closing the lens a little, and then open slowly until zebra just appears. Re-check the value. If it is different from 90 per cent, repeat the above until it is correct.

These procedures are not obligatory but the background to them must be properly understood. There is no point in doing them parrot-fashion. This is the business of pictures and these must be created from a mechanical but perfectly understandable system of video. Pictures are individual, no two people can produce the same picture so each makes different demands on their kit. Each must develop their own method of how to

check it out, irksome as this learning process may seem to be. Then, we can decide how much of it applies at any one time.

## In studio

We now turn to a studio environment. Many of the points already discussed apply to multi-camera working. This next section is therefore an extension of single-camera operation.

*Camera line-up*

This procedure was noted in days gone by for its formality; in some cases this was almost ritual. There were good reasons. Early cameras were complex in setting up and were prone to set-up drift. At the same time, it was recognized how important properly set-up and well-matching cameras were to a programme. The discipline of camera line-up came about to cope with both of these. It was essentially an engineering discipline, for the task was an engineering one; the legacy we have today is a mixed one.

Many of the principles are still relevant. Modern cameras now have a degree of reliability that renders constant engineering attention unnecessary. What still remains, however, is the matching requirement, and, a particularly important feature of formal line up, a need for confidence that it will do what you expect.

Just as with a single camera, preparation establishes operational suitability and, therefore, confidence. And, as before, we must deal with the monitors as well.

Because there is a growing requirement for people to move between traditional disciplines, it is valuable to understand how the problems and procedures may be extended into studio control rooms. Photographers must be able to function in both situations. Here, camera responsibility comes within the role of vision operator, or vision engineer. Note that the term 'engineer' is used somewhat the same as it is in the world of audio: to describe someone who deals at an operational level with technical facilities. The photographer may be just as likely to use light inside a studio as outside, so this part of vision engineering is well worth knowing about.

Studio monitors are usually confined to the control rooms. These are normally of a much higher standard than the television-based displays used on location, and are quite often graded 1 or 2. These are more accurate, and have more facilities available.

Where a monitor is used on the studio floor, it falls into the same category as those already described. The use of a mobile Grade 1 monitor on the studio floor requires particular care with regard to ambient light falling onto the screen. Failure to take this care will entirely negate the advantages of this quality of monitor.

Lighting conditions in a control room should be designed for a higher grade of monitoring. Proper picture line-up facilities may be available to set brightness and contrast. Contrast may be set to the monitor designer's recommended value by optical measurement. Using a standard exposure meter is possible but care must be taken. Digital ones may not be designed to function with a non-continuous light source (the picture frame rate may confuse the metering). Traditional analogue types have a magnetic field that will easily magnetize the tube's mask that lies just behind the screen. Do not use these, for this condition can be permanent. A spot meter will be desirable for measurements to be made at a working distance. Meters may provide monitor set-up attachments.

Use the methods laid down by the monitor manufacturer. The aim is first of all, to operate them correctly, and second, to achieve a close match from monitor to monitor. The second point is as important as the first. Mismatch will show; after some hours the smallest errors start to irritate. These errors may be too small to measure, but the eye is very well able to see them.

It is the eye that must perform the final trimming of set-up. It may be necessary to degrade one monitor to enable a completed matched set. But where the eye is unforgiving over differences, it is less so over absolutes. This will be more complicated if more than a single type of monitor is used. Only experiment and practice will resolve this problem.

Brightness is critical but a picture set-up facility will answer the need. The most common is called PLUGE, a BBC development that has found its way into many installations. It uses two small black bars, one 3 per cent above and the other 3 per cent below video black, to set brightness accurately:

1. Carry out the procedure in operational lighting.
2. Adjust the brightness so that the darker bar is just showing.

This is critical setting. By making the darker of the two bars just visible, the brightness is set very slightly raised, giving a safety margin against the picture being crushed. Compare monitor to monitor and trim to match.

PLUGE also has level steps, the highest being 100 per cent. This is measurable, so that the contrast may set to give the desired light output. The intermediate steps may also be measured so that comparisons may be made.

If full monitor line-up is not available, Vical may be used. This will make it necessary to set up each monitor individually as described in the single-camera procedure. But precise settings may be achieved:

1. Use the Vical set-up mode with the grey bar at 3 per cent.
2. Set the brightness until the grey bar is just visible.
3. Instal Vical in each monitor feed in turn and set up.
4. Measure the white bar and adjust contrast as before.

This is a less convenient method but as the grey bar is not restricted to 3

per cent, the setting of brightness may be customized to suit individual requirements with other settings.

For setting up monitor saturation use colour bars, as with the location method, display blue only and measure the blue bar at 75 per cent. Using Vical is the only way to set monitor saturation properly.

The control room will probably be equipped with two or three monitors of the same grade: lighting preview, vision control preview (sometimes shared with lighting), and an 'on air' or transmission monitor. They should all match closely. Control room monitors are subject to the greatest scrutiny for they are the final point of the quality check. It is very important to check them out before programme use. This will mean powering them in good time for them up to warm up and stabilize. Modern ones do this quicker than older ones. Allow at least an hour for the former; 15 minutes may be sufficient for the latter. But if they are in use for 12 hours or so, be prepared to check during breaks.

Camera line-up is now an operational procedure and will therefore be a much more common check than formal line-up. Modern cameras no longer require this and so this is more of a preparation to suit individual programme requirements. There are a few principles that still apply.

*The line-up light and grey scale*

Modern cameras have many, or all, of their parameters held in software. Computer memory is smaller and cheaper than the mechanical system of variables with all those pre-sets called 'pots'. Software is also very flexible; control can be remote, and a number of different settings can be held and changed *en masse*. Individual programme settings can be memorized and stored ready for instant recall. So, one can argue that all set-up and preparation, and the time it takes, is redundant. This may be true, until the unforeseen happens and something goes wrong.

This may be a camera mismatch, or a different exposure sensitivity, or an unexpected colour cast. This is embarrassing, and preparation should go a long way to reducing this. Start by getting all the cameras available to you in good time. This is a once-only event before the first day's work and a worthwhile investment in time. Allow half an hour with unknown cameras. Studio space to set out the cameras is not always easy to find in overcrowded studios, but a word with the programme's scenic designer (art director), to negotiate a space where all cameras may be assembled, should resolve this problem.

Position a lamp to illuminate the grey scale chart. The level of light is yours to decide if you are lighting the studio as well. If not, the lighting director will indicate what it should be. It must be representative of studio lighting levels, and the lights must be of similar type, e.g. tungsten. The studio lighting level will affect depth of field, which is a photographic parameter. It will also affect studio heating and running costs. If there is too much light, the studio pays for the extra heat and then for the air conditioning to get rid of it. Operational lighting levels are usually

predetermined by the lighting system design, so choice of lighting level will be dictated by this.

Illuminate the grey scale chart and measure the incident light at the grey scale. Choose lighting that will be representative of that to be used for the programme. Always use incident light readings, i.e. the light falling on the grey scale, but ensure that the meter sensor faces the cameras. In this way the reading will be corrected for the angle the light subtends to the grey scale–camera axis.

Colour temperature and level should be the same as that of the studio set lighting.

1. Group the cameras tightly and frame them in identically, as far as this is possible, on the grey scale. Focus each carefully. At this point it is often worthwhile to quickly check back focus (sometimes known in studio as zoom tracking). Point at a distant object, zoom in and focus. Zoom out slowly and carefully check that sharpness is retained. If not, adjust the lens back focus control.
2. View the pictures from the cameras in the control room. The monitor chosen for this should be at the vision control preview position. It is this position that deals with the camera control of exposure, picture black and colour. It is also the assessment position for picture quality. Here, all the camera controls appear on the operational control panels, or OCPs. The principal controls are joystick operated, with exposure controlled in a forward–backward movement and black by rotation.

Note also how the terminology has changed. This is the result of the subtle influence of engineering in studios and of film outside. The terms 'lift' and 'iris' refer to picture black and exposure. This influence also affects colours. In a studio system where the camera work from an OCP, full control becomes available. The control of colour is twofold: colour lift and colour gain, which may be variously known as colour black (or pedestal) and colour paint. The most useful thing to do at this point, if there is any doubt about which is which, is to experiment (with restraint!).

Let us return to our camera pictures and a few basic checks:

1. Quickly check that the OCPs function – iris, lift and colour.
2. Iris all the cameras to close, i.e. all pictures will be black.
3. Observe both picture and waveform monitor. Adjust the lifts to make them the same, about 3 per cent. Check the colour of the individual camera picture blacks. Vical is an aid here, if available, in assessing what is true colourless black and in setting the 3 per cent pedestal if so desired. Colour differences are corrected with colour blacks. Some practice will be involved if you are not used to assessing colour errors.
4. Open all the lenses, and iris to make the grey scale background about 50 per cent. Note how well the cameras match each other at the various levels of the step wedges of the grey scale. Selecting each in turn and watching the waveform monitor will quickly show this. Always

relate what is seen on the waveform monitor to what the picture shows. It is very important not to become reliant on the waveform for picture assessment.

Colour differences in the picture greys will also reveal themselves and these may be corrected by the colour gains.

Check also that when exposed to exceed peak white, all the cameras reach 100 per cent, no more, no less. In other words, all peak white clippers agree at 100 per cent. Your waveform monitor will indicate this.

This procedure is the basic principle of operational line-up. It ignores some practical points. In the first case, the cameras may well have the ability to do all this themselves. There is auto black balance and auto white balance, just as in a single camera. These may be initiated from the OCP. But unless you are familiar with the basics, particularly regarding what you need to look for, the effectiveness or otherwise of these 'autos' may well pass unnoticed.

It is here that you may have control of gamma as well. This powerful control should not be treated lightly. Unless it is available in discrete values, avoid altering it unless you are very confident that you can restore the original values. Even more intricate can be colour gamma. All three colours are individually gamma corrected and the option may be available on some advanced operational panels to alter these. Beware. These are very complex operations; unless you are experienced and have plenty of time, avoid these.

Should your simple grey scaling of the cameras fail to result in a good grey from black up to white, colour gamma may, indeed, be the culprit. Or the problem may be, just as easily, something else. Unless the error is embarrassing, and only experience will say how significant it will be, avoid altering anything.

These are the sorts of situation one finds in multi-camera operation. Camera matching is the single biggest time consumer in camera line-up. It takes experience to interpret from a grey scale to a real picture situation. This only comes with time. The time you spend before the programme starts is too vital to waste on the least significant aspects; concentrate on the essentials of blacks, greys and whites. Prove the basics of the system, that it is good enough to commence work with. Make notes of other points for attention later.

## Looking after the kit

Care of video equipment is straightforward. Basic cleanliness is best ensured by storing in a properly fitted box. It is usually the mechanical parts that suffer from foreign matter; the electronics are quite sensitive to fluids.

In use, all manner of hazards can appear. Rain is usually kept at bay by an operational cover. The lens is the most obvious part to keep free from rain, but care should be taken to keep tapes and the recorder tape

transport dry, for these are moisture critical. Worse than rain is salt spray for this is corrosive and penetrative.

Worse still are drinks. These contain some of the most destructive agents, from sugars to salts to acids, and if equipment suffers a serious contamination, the necessary action is drastic. Switch off, remove batteries, remove covers, and dowse the contaminated parts with clean water. Then dry thoroughly. Lens and optics will, unfortunately, need stripping down afterwards, but you need to act quickly if you are to halt corrosion. The mechanics of the recorder may have escaped the attack if the seals are in good order. If so, avoid this area and concentrate your efforts on the camera body. If it is the monitor that must be dealt with, wait some minutes for the high voltages to decay before using water. Keep drinks and food away from equipment.

Dust is another problem to be aware of. It is not always apparent until it reveals itself as a layer over the exterior. It can also find its way into mechanisms and may be particularly damaging to tape and tape transport. If dust is present, avoid moisture. It is best removed with pressurized air from a can, *not* a compressed air-line. Failing this, use a puff of good clean breath, avoiding moisture.

Always clean equipment after use and refit covers and caps before putting away.

# CHAPTER 8

# SHOOTING FOR SPECIAL EFFECTS

They say the camera never lies, which is true. But the photographer is only human . . . .

## Process photography

The more one studies photography, the more one realizes that there is very little that is really new. Compositing, montaging are forms of process photography, manipulation that has been practised and understood for many years. Horace Nichols, a photojournalist in the 1890s, used compositing as a means of producing the photographs he required for magazine publication.

There are two primary ways to manipulate: in camera and out of camera. The former is common in film work, both still and movie, with workers specializing in film and optical manipulation with multi-exposure effects.

Video manipulation is done out of camera as a studio mixer live effect, or in post-production. Live effects can be made as they are seen; this simplifies the task appreciably. Post-production effects must be seen beforehand in the mind's eye.

This requirement for preconceiving the final composite is the foundation of its success. There is, none the less, a very great deal of manipulative work done at a remedial level. In television, the need to remove after shooting the all-to-common television aerials is a good example. An indicator of the medium's success is how often these are removed at some later date!

We now have two distinctions, the planned composite and the afterthought. Our concern here, however, will be to look at the former in the expectation that this knowledge will reduce the likelihood of the unexpected appearing afterwards. To understand the principles and to go through the procedures is to offset many of the problems that only manifest themselves afterwards. Remedial work is not necessarily the responsibility of the compositor.

*Constructing the image*

In Chapter 5 we discussed the basics of picture construction; how pictures work and sometimes fail. Compositing is an extension of this, where the picture is seen before the camera in part only. The other part will find its way in by some means later. Today, with electronics, digital video effects and computer generation, this has become more and more common. The image has to be constructed in the imagination first, and no machine can do this.

*The master shot*

This is the first principle of compositing; the creation of the master shot. When putting two images together, only one may be dominant in that the basic structure of the shot will be determined by that one image. This rule does not become invalid simply because the master shot is an incomplete image. There may be no subject in it; for instance, the players may be added later. But its structure will determine the second image and the way they are put together.

The structure is determined by many factors. Here are six important examples:

1. Framing. This decides what parts of the scene are to be altered. The extreme case is where framing may remove the requirement entirely. In other words, it may be possible by careful framing to avoid compositing. The classic example is that of television aerials. Framing is crucial to place the elements of the scene in the correct places. This will make the composite predictable, and easy to manipulate. The easiest framing will be one where rules of composition are observed. It is confidence that allows rules to be broken successfully. For a composite image this confidence has to be transmitted to those that follow. The simpler the framing, the better.

2. Lighting This has the greatest influence on the shot, and must be matched in the final composite. Easy-to-observe lighting is important. Avoid conflict of direction, for what may work in the original may not easily transfer to the composite. If the lighting is obscure, state this in the location notes; the compositor may have to 'make' light that is more precise.

3. Perspective. Photography, because it records three dimensional space as a flat image, creates perspective. This may, however, be distorted by lens angle or geometric lens distortions. Perspective in a composite must be created from the original. False lens perspective is not easily transferred from master to composite with conviction. Avoid too dramatic a perspective by keeping the camera level. Aim for the horizon to lie between the top and bottom thirds.

4. Lens angle. This must also be matched in the final composite. It has considerable control over how the additional work is created, for there are many variations of lens angle in common usage. It is related to perspective and the same points apply. Use the 'standard' viewing angle.

5. Movement. This affects how the eye sees the final version. It may distract or complement. Movement inserted later will influence the composition. It is important to know what this is before shooting the master.
6. How long the shot will be. The longer the shot, the more care must be taken with it. The eye will always be aware of a change to an image, regardless of whether it they realize this. The longer the shot, the more chance there is of seeing something not quite right.

These factors, of course, are not unrelated to conventional photography, for the intention is the same: to create a true image, i.e. one that is acceptable to the eye. And a true image has to 'work' in just the same way whether it is make-believe or not.

In Chapter 5 we considered the eye and its response to stimuli in the picture. The eye has the final say. One of the important considerations in manipulation is retaining the confidence of the eye. When this is lost, the shot is lost. Our master shot must, therefore, have all the necessary foundation material of the final version.

Let us consider one of the oldest forms of manipulation.

### The glass shot

The glass shot is an example of compositing in real time; whilst it is compositing, it is not the same as producing an original and packing it off for someone else to complete. But it does demonstrate the elements of joining together two parts to make a final picture. Clearly the master is the scene

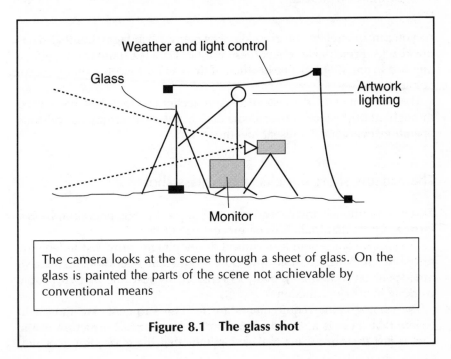

The camera looks at the scene through a sheet of glass. On the glass is painted the parts of the scene not achievable by conventional means

**Figure 8.1   The glass shot**

beyond the glass, for it is on this that the final is built up, even where this may be only a tiny portion, say a character moving in the scene, and real scenery can be limited to backing this movement only. Everything about the scene is fixed by the camera, framing, lighting and shot angle. The artist, with paint and brush, adds the rest in harmony to the glass.

In this lies the secret of the success of the glass shot – real time. Both photographer and compositor, camera and artwork, are present at the time of shooting. All the elements of compositing are dealt with as they arise, particularly those set out above.

To carry out a glass, the following will be required:

1.  Time to carry out the work. Painting can be a long process.
2.  The camera and glass must remain in exact positional relationship to each other once the artist has started. Movement of either is out of the question, so fine is the registration between the shot and the artwork.
3.  Lighting the glass correctly is very important. The artist has to have space to work, and lighting will need to be flexible, yet consistent, to match the original.
4.  Ensure that changes to the weather can be coped with.
5.  The shot may take so long to complete that changes in the sun's angle upset the lighting. The artwork has shadows that are painted in.
6.  Protection against the elements. Cover the whole set up, even if only to ensure the comfort of the artist.
7.  Monitoring. The artist requires good monitoring. A grade one monitor is the only way to guarantee the result. Protection against ambient light will be required.
8.  Patience.

As you can appreciate, the glass shot has many advantages, but it also has drawbacks. Principal amongst these is time. Time is expensive, keeping a unit tied to one shot must be justified. If this can be done, the shot is worth doing properly.

The glass shot is a most successful technique that has been used throughout the history of the cinema. Its success results from the real-time operation; everyone is present together.

## The process shot: the electronic glass shot

This is a traditional cinematographic technique. Process photography is a form of filmic manipulation, or processing. Electronic or video process photography came about as technical developments provided video tape recording, making possible this post-production operation. Expensive time spent on location by many is replaced by just one or two people working in post-production.

The photographic requirements are no less stringent. We must still ensure that there is a sound photographic concept; the structure of the shot is just the same. This makes demands that the glass shot does not.

The concept has to be worked out in isolation; the composite is imaginary. One must, therefore, establish the production intention quite clearly. How long will the shot be? What will it be cut into? Which are the important elements of the scene?

The practical requirements are strict. Although the time taken to shoot a process shot is only as long as the shot lasts, there are important considerations:

1. There must be no movement of the camera. As with the glass shot, the camera must be rigidly held. The electronics replace the glass but accurate registration is still required. Video has a distinct advantage over film in this respect; it is a rigid medium. There is no film weave with video. The camera must be held firmly, as even wind shake will cause problems. These conditions of rigidity are essential, unless the facility of frame-by-frame compositing is available.
2. Avoid movement, including shadows, that crosses the matte line. The matte line is where the process photographer will join the separate images together. Any movement in the shot that crosses where this line will run will disappear behind the artwork. And also watch out for that bird silently swooping behind the artwork!
3. Avoid optical effects. Filters can diffuse light over a wide area. If optical flare or diffusion crosses the matte line, it will also disappear behind the artwork. Its replication in artwork is often difficult. A serious problem is often created by smoke. It may break the matte line, for it does not always blow in the same direction.
4. Beware of lens geometric distortion. Any bending of verticals or horizontals will affect the construction of the final image.

If there is any flaw in the final image, it will look like what it is – a visual trick. For the uninformed viewer the flaw may not be apparent, but the result will be the same, an unconvincing shot that gets in the way of the story. The longer the shot is held, the more demanding it is. A well-executed five-second shot will probably hold without ever being spotted. One of 30 seconds is a very different matter.

Find out how long the shot is to be held for, and be wary of the answer. It may differ from what actually happens in the edit.

*Planes of the image*

Process shots may be complex with more than one layer of effect. The most common effect is to replace backgrounds, sky and skyline. Here there is a single plane of process work to be added. It becomes very much more complex to add other planes. Each has to be supported by, or supportive of, the others. Try an experiment.

Cut out of a newspaper photographs that seem similar or related. Now, cut out features from these and attempt to composite with them. Although the photos may appear to match, it is quite another matter to make them work as a whole. Visualizing this on location with only one part of the picture, that in your viewfinder, is not easy.

Where the scene is broken down into planes, compositing can use these as natural breaks between images. An image becomes difficult where the images cross over in depth and background and foreground elements mingle. These complex shots demand as much assistance as possible from the photographer, following the basic rules of framing and lens angle. The more complex the shot is allowed to become, the more variables the final image has that may go astray.

The compositor has only the original master to go on; all the clues for the final come from that master. It is surprising how sparse these can be. Clues sometimes conflict. Very commonly there is a mix of lighting that is not very well thought out. It may not have been considered important at the time, but may become quite crucial in later preparation of the final composite.

As planes are added to the original, say a new distant skyline and cloud, with buildings in front, all this has to be fitted into the original scene dimensions limited by real foreground and real sky. The compositor may have to replace the sky if the original depth is insufficient. In particular, the effects of perspective and lens angle are significant. For a simple insertion of skyline that occupies one plane, these factors are less significant. But as further planes are added, so these will be more important. Both lens angle and perspective are interrelated. As the lens angle increases, so apparent perspective increases, and the shot deepens. Conversely, the shot shortens as the lens tightens. Aim to use a lens angle between 35° to 55° to keep the scene perspective as predictable as possible.

In practice, it is often very difficult to manipulate all this visual complexity in the imagination. The only answer is to cover it as best as possible. Trial and error using stills is also a valuable aid, this is simple to carry out at a planning stage, and will often point to success or failure.

Where there are complex and demanding shots with high expectations placed upon them, it is well worth the process photographer, artist or compositor being present at the time of shooting. This removes this highly specialized responsibility from the photographer and places it with those destined to complete the project. The shot then becomes the product of a very effective team.

### Chroma key

Chroma key (CHK), or colour separation overlay (CSO), is where part of the scene is identified by the electronics and replaced by other scenic elements. This is another cinematographic effect developed to take advantage of the electronic processing available to video.

The electronics are triggered when the chosen colour exceeds a certain value. As the signal passes through the system it is analysed, first, for hue (what colour it is), and secondly, for the amount of colour (its saturation). If both criteria are met, the system switches over to the other picture. By making this a dual requirement, it becomes very selective. From the

colour a keying signal is generated that activates the electronics to switch from one picture to the other.

The original shot, containing the chroma key colour is known as the 'foreground'. The inserted signal is the 'background'. Conventionally, it follows from this that foreground figures have the background keyed behind them.

The concept of the master shot holds true in chroma key, for this shot states the visual parameters of the final composite. One must, however, establish the relative importance of the two parts to ensure that they are complementary. Chroma key operation requires just the same attention to the final concept as any other shot.

The choice of key colour is traditionally blue because it is a colour of low luminance content, i.e. high saturation, and is on the opposite colour axis to flesh tones. Blue was therefore the first choice for colour separations in film. The blue screen in studios is very saturated and therefore relatively uncommon in natural scenes. But one must obviously avoid blue clothes and blue sets in this operation (and blue eyes as well).

Since the arrival of chroma key in television, the use of other colours has been introduced. As video is based on red, green and blue these soon became available as chroma key colours. It was soon appreciated that the complements of these would also work, and cyan, magenta and yellow chroma key colours appeared. With even more sophistication, it becomes possible to choose any colour. In practice, the choice depends upon what paints or dyes there are available for covering large areas of studio. Blue, therefore, still remains a firm favourite.

With these technical improvements has come the ability to distinguish more easily between the key colour and others near to it. Key colour suppression is another valuable addition to the armoury. The key colour is so strong that it may be seen around the cut-out, or matte line. By suppressing the key colour so that its grey or luminance value is all that remains, much of the distracting edge effect is lost.

In shooting chroma key it will be useful to know what system is to be used. In studio real-time chroma key, we can see the effect as it happens. But the keying is very often done later. The recording medium then becomes quite important. A digital recording will add no distortion and the chroma key can be recovered intact. Component recorders are able to provide quite a reasonable key signal off tape. Fortunately, composite recording is less common, for here the key signal can only be recovered after the PAL or NTSC signal has been decoded. The key signal is often so imperfect after this process as to be very difficult to use.

This is also a consideration where signals are to be dispatched over any distance. A composite, or encoded PAL or NTSC signal carrying a chroma key element, will suffer distortion to some degree. A digital circuit, if this is possible, is the answer to this problem.

Chroma key is a specialist technique. Its technical base cannot be ignored. It is important to get the exposure of the key colour. As a rough indicator of exposure, compare the colour level to the similar colour in the

camera colour bars. It may be necessary to light the screen separately to get a sufficient level to guarantee a good key in the edit.

Measure the level of the key colour with either a waveform monitor or Vical. Use colour bars as a yardstick. It is most unlikely that a scenic colour will in every case match that in colour bars but blue chroma key should be between 20 per cent and 30 per cent. If it is a lot higher than 30 per cent there may be impurity in the blue that increases its luminance value. This is not necessarily the fault of the paint or dye but may be due to reflections or dirt on the surface. Too high a value is not desirable, for it may cause the camera–recorder system to be overloaded.

To accurately measure colour saturation values for chroma key a waveform monitor or vectorscope is the answer. These are able to remove the

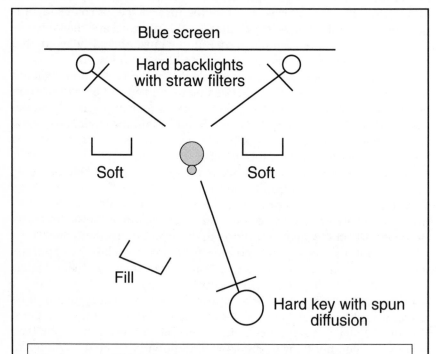

The key is a diffused hard source. If shadow is required it must fall onto (blue) floor cleanly. The amount of diffusion must not be too great if a clean keyed shadow is to be achieved. Make sufficient space between subject and screen to avoid the blue light spilling forward. Hard backlights have (optional) straw gels to cancel blue spill onto the figure should this prove to be a problem. The blue screen is lit with soft sources to provide even coverage. To avoid spillage onto the figure these must be kept behind the figure

**Figure 8.2  Simple chroma key lighting**

luminance element, leaving only the chrominance, allowing us to 'see' the signal just as the keying processor will. Such methods rely on a reasonable technical understanding but in complex chroma key operations, or if you intend specializing here, these are worth investing in.

Lighting a chroma key screen correctly is critical. As with any shot, the subject and backing need physical separation between them in which to get lighting. With chroma key the situation is the same. To effectively illuminate the screen you will need space. Visually this space is unimportant for it will be filled by the background image.

This separation is also important, for blue light thrown forward from the screen does not result in a blue cast on the sides of the subject. This is sometimes difficult to eliminate and it may be worth having available additional subject lighting to offset it. The key colour complement may be a useful lighting gel to have. The complement of blue is yellow, and a straw (one of the Wratten 81 or 85 range) filter on three-quarter backlights on the subject will help. Here, we have another advantage of blue chroma key; a yellow light on a face may not be too objectionable.

Shadow chroma key is another area of consideration. Shadows from the foreground subject may be reproduced in the composite. The subject shadow cast onto the chroma key screen changes the value of key signal. This is utilized in the keying process to reduce the level of the background image. Where the shadow falls on the screen, the background will be inserted at a lower level, i.e. it will be darker.

Shadow chroma key is most effective when carefully planned. The distance of the screen from the subject is now important for realism. The way the shadow falls will be mimicked in the composite and this must be considered too; it is affected by the screen angle as well as position. The lighting of the screen may be compromised to achieve these requirements, so affecting how well the keying works.

## Camera complications

The limitations imposed by the technicalities are similar to those affecting all video photography. The system limits must be observed, although if your camera is set to produce signals over 100 per cent limit, this will be of some advantage in accepting a high level of chroma key. By the same token, if the camera is equipped with auto contrast control (the effect of 'knee'), then it may put restrictions on how much signal the camera is able to reproduce.

This will be a particular nuisance when attempting a 'white out' effect. Any form of contrast control that holds back the highlights over 85 per cent will make it difficult to light a white background to make 100 per cent. Also, this dynamic or auto contrast control will change the level of the backing, depending how much area it occupies in the shot. Its value will, therefore, be constantly changing. Switch off this control if it is available.

Because the camera has to operate near its design limits in this way, all its functions must be set up properly. The excessive amount of key signal causes errors to show and, despite the keying out of this signal, its artefacts may be spread around into real picture. This is particularly so with colour cast. A significant part of the signal chain is associated with correcting flare. This is aimed at that spillover of light in and around the three-colour splitter block. Electronics are very successful at correcting for this but, if they are imperfectly set up, chroma key will show the shortcoming.

Shooting for compositing is very specialized. An understanding of picture construction, perspective and composition is essential. Regardless of these, it is becoming more common and varied in its application. For just as electronics have improved the performance of chroma key, so computers have advanced picture manipulation. The result is a mushrooming of compositing using digital effects that find their way into all forms and styles of programme.

Only one thing remains unchanged – the eye. The eye is still the final testing point of photographic success. Pictures must 'work' whether composited or manipulated or not. Each addition to the picture must be built up with care to complement the original and other additions. The success or otherwise depends on the original concept. If that is flawed it makes it more difficult to make the process operation convincing, and sometimes it can lead to failure.

# *Appendix*

# SAFETY AND DISCIPLINE

To be safe is to be able to work with others. We depend upon each other so that our work may be effective.

Safety is the responsibility of us all, individually and collectively. We must:

1.  Ensure our own safety.
2.  Ensure we do not endanger others.
3.  Deal with unsafe situations promptly and correctly.

Safety and discipline go hand in hand. When the going gets tough, and people are tired, uncomfortable and under stress, we rely on our personal discipline to carry us safely through.

To provide answers to all the widely differing instances of safety and personal responsibility is not possible here. We must take time to make ourselves aware; to read safety notices and know the local conditions and regulations. We must beware of the unknown and treat it with respect. This is personal responsibility.

Lack of time to do these is no excuse when an accident happens. It is certainly no excuse to offer an injured colleague.

Discipline is the way we work and organize ourselves. It requires:

1.  Understanding of the work.
2.  Understanding of others.
3.  Responsibility to others and to the work.
4.  The acceptance that everyone else has their own responsibilities.

## Crewing: or working together

Working together is collective responsibility. Individual responsibility expands to include fellow crew members. It is the team relationship that makes a good programme safely. Because of the nature of the job, locations and studios can be potentially the most dangerous environments to work in. The safety record is so good because of the professional discipline and responsibility exercised by all.

For an individual to alter parts of the system that may affect others without saying so, no matter how good the intentions, is bad operating discipline. The reliance we place on others must be reciprocal.

The value of good time-keeping and being properly prepared is invaluable when working closely with others. Knowing when to speak out and when to shut up is also important. Studio control rooms are close-knit communities; there are excitements and gripes, moments to remember and those best forgotten. All share in everything. To keep one's head and concentrate is discipline. Advice is only valued if it comes when it is wanted and it is correct. This takes practice.

An overall experience develops of how a production functions. But everywhere there is the need to work together, sometimes even live together. A crew has a wealth of experience that will be readily imparted to the newcomer who shows ability, thoughtfulness and personal discipline.

# GLOSSARY

**Amateur**   One who works for the love of it. Professionals may not have this choice.

**CCD**   Charge Coupled Device. A silicon pixel array onto which the image is focused so building up an equivalent electric charge. This is then read off by a microprocessor to appear as the video signal.

**Colour co-ordinates**   A standard used to define any particular colour.

**dB**   Decibel. Amplifier gain expressed on a logarithmic scale.

**Digital**   Where the signal or process is in digital or binary form. May be controlled by software.

**Encoding**   Converting component video to composite PAL or NTSC.

**Fresnel lens**   A convex lens that is reduced in depth by converting to annular prisms.

**Gain**   Signal magnification by an amplifier. Amplification.

**Liquid crystal display**   (LCD). A low power picture display made up of an array that changes reflectivity, or transmission, with applied voltage.

**Microprocessor**   Digital manipulation chip.

**Microsecond**   One-millionth of a second.

**Monitor**   Picture display with video input.

**Monitor grades**   Grade One monitors are the most accurate picture monitors. Grade Two monitors are the next level down.

**Monochrome**   A one-colour picture. Often used to describe black and white.

**Nanosecond**   One thousand-millionth of a second.

**Receiver**   A receiver of TV transmissions. A television set.

**Splitter block**   The red, green and blue light separation block in a 3 CCD camera.

**Story board**   An pictorial shot guide.

**Telecine**   The film to video transfer system.

**Upstage**   That part of a scene that is just beyond foreground.

# BIBLIOGRAPHY

Henderson, H. (1964) *Colorimetry*. Engineering Training Department, BBC.

Hodges, P. (1993) Vical. A Video Calibration System using a Standard Picture Monitor. *Journal of Photographic Science*.

Sims, H. V. (1969) *The Principles of PAL Colour Television*. Engineering Training Department, BBC. Iliffe.

# INDEX